A Guide to
Marine Photography

A Guide to Marine Photography

by Pete Smyth

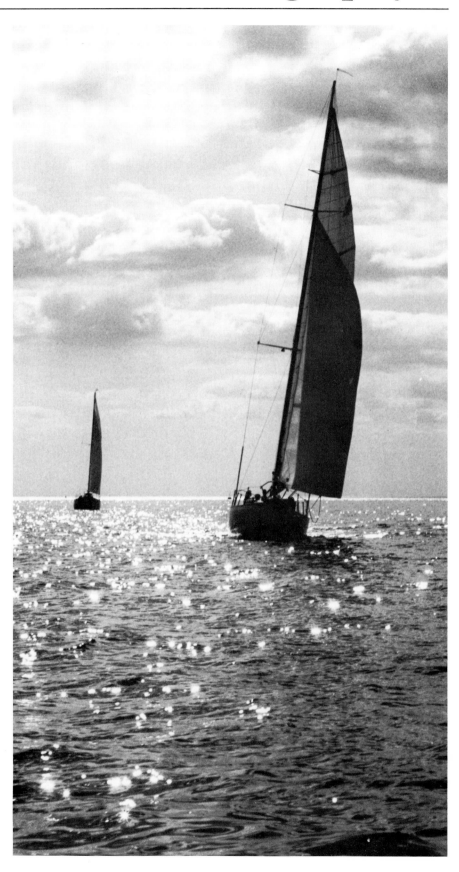

Of all the varied aspects of photography, marine photography has to be among the most simple, the most complex, the most frustrating, and the most rewarding. Simple because the complicated equipment of the studio photographers is of no use whatever; complex because the interrelated factors of wind, sky, sun, and sea must all cooperate with each other and with the photographer for a photographer to be successful; frustrating because these elements rarely do cooperate; and rewarding because when they do the chances of achieving real art are high.

Marine photography is a world unto itself and we who have met with some success at it chuckle quietly when we see an experienced photographer from another area come to the water. With portfolio of credits under his arm, and wide-angle Nikon at the ready, he shoves off to do battle, and however good he may be in his own area, he will soon go aground on the shoals and reefs of our special craft. Since I have spent more time than I wish to recall upon those reefs and shoals, I can speak of them with considerable authority, and I am hopeful of charting some courses which will help the fledgling marine photo buff avoid them. Plotting these courses between the Scylla of overexposure and the Charybdis of eye-level shooting is what this book is all about.

A Weekender and another sloop keep company on the sun-flecked waters of eastern Long Island Sound. (Rollei, yellow filter, Tri-X, 1/500 at f/16.)

Copyright © 1974 by Peter R. Smyth
First Edition
Library of Congress Cataloging in Publication Data
Smyth, Pete.
 A guide to marine photography.
 1. Photography of ships. 2. Photography—Marine.
I. Title.
TR670.5.S58 1974 778.9′9′3872 74-13741
ISBN 0-393-03182-9

This book was designed by Marta Norman.
Typefaces used are Times Roman and Caslon Bold.
Set by Spartan Typographers.
Printing and binding were done by Kingsport Press, Inc.
CREDITS
Photographic prints by John R. Kennedy.
Many of the photographs
are reproduced by the courtesy
of the Hearst Corporation.

Printed in the United States of America
1 2 3 4 5 6 7 8 9 0

Contents

The Frustrations and Satisfactions of Marine Photography

Attempting to take photographs on the water clearly illustrates the truth of the old adage that man proposes, but God disposes. As with the sailor, the waterborne photographer is hopelessly dependent on the elements. Thus, the basic, ever-changing realities of wind and water provide marine photography with both its frustrations and its fascinations.

And the world of water and sea and land and air and boats and boatmen is very real. It needs no glamorization, no embellishment at the hands of some artsy-craftsy nut last seen doing funny-looking pictures of weird women for a fashion magazine. The marine scene only needs faithful recording.

But this isn't as easy as it looks. Life on the water employs all five senses to their fullest. You can smell the sea, you can feel the sun, you can taste the salt, you can hear the symphony of wind and waves and boats—and, of course, you can see the whole—in motion. The problem, therefore, is to record the smell, the sound, the taste, the feel, and the events in a static photograph. The viewer's eyes must double for all other senses.

To accomplish this is, of course, an impossibility; to approach it is possible but it does require effort and work. Like all other art forms, marine photography may be simple (as we shall see) but it isn't necessarily easy.

I found this out the hard way soon after I was backed, by sheer necessity, into buying my first camera, a twin-lens Yashica. This was nine years ago and the occasion was my dive into freelance writing. My first visits to editorial offices for assignments convinced me that learning to take pictures was an essential.

As luck would have it, my first expedition—to the Virgin Islands—turned out fantastically well. I'm still using photos shot on that trip and some of them appear in this book. What I didn't know at that time, though, was that taking good photos in the Virgins is about as difficult as avoiding sunburn in a coal mine. In fact, if you can't take acceptable photos in the Virgins, you should take up another hobby and give up photography.

However, I must say that I went to the Virgins armed with a background that, in retrospect, allowed marine photography to come more easily to me than to others who have not had the advantage of (a) a lifetime on the water, (b) a reasonable amount of boat design experience, and (c) a fair amount of experience at writing, which at least trains a person to be watching for story ideas and storytelling details.

These, taken singly or in combination, seem to make going to the right place to obtain the right composition, the right angle, and so forth at least half instinctive. A clear example might be the photography of a sailing race. If you have raced extensively yourself, you can, for example, anticipate and get in the right place to shoot the dramatic port-starboard crossing, and you can keep clear of possible interference.

Further, a long study of boat design

On a day like this, who wouldn't sell a farm and go to sea? The boat is Agamemnon, *the occasion the Mystic schooner races of 1972. (Rollei, Ektachrome, 1/250 at f/11.)*

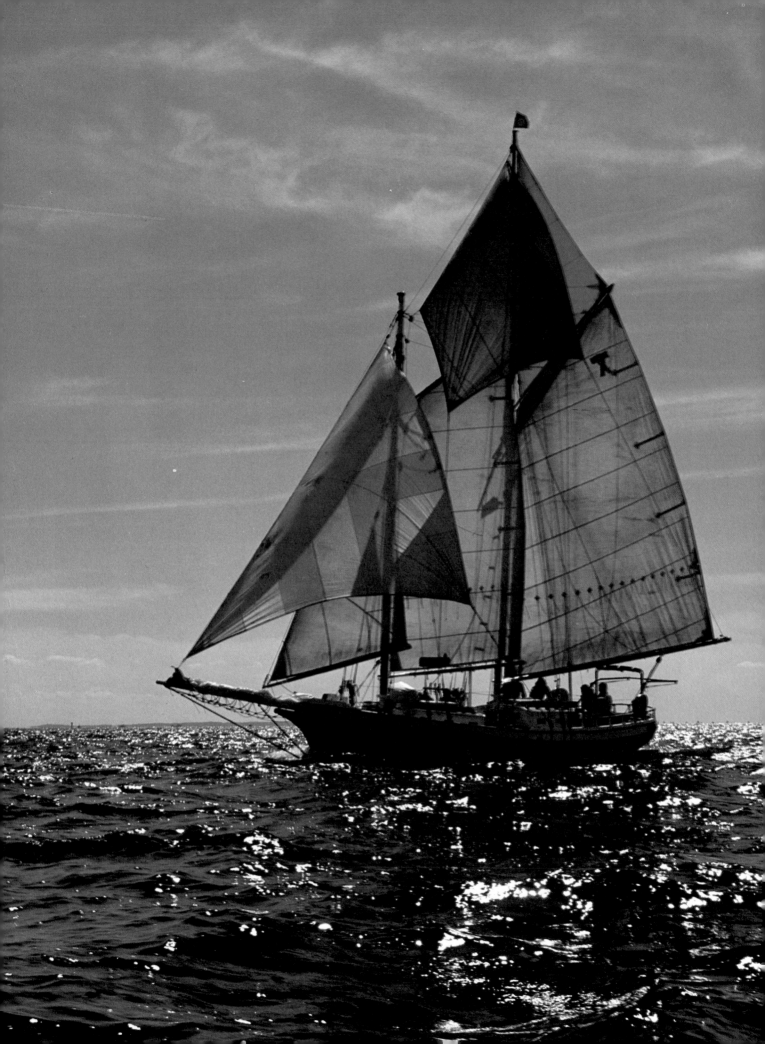

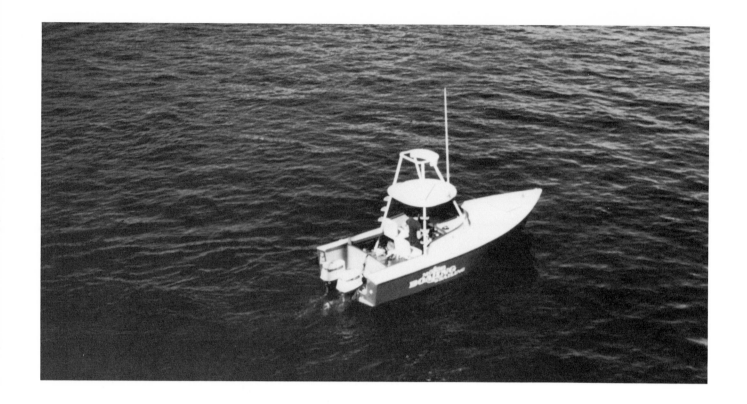

(and I must admit that my own design concern has always been far more oriented toward aesthetics than performance) makes selecting the better shooting angles far easier than it is for a person without this background.

And finally, a long and intimate association with the water provides a great deal of information (some instinctive) about what's going to happen when, and what it is going to look like. To the sailor, a highly developed weather and sea sense is important—to the marine photographer, it is vital.

The importance of this can hardly be overemphasized since, as we said in the beginning, when you are shooting on the water, you are indeed at the mercy of whatever the weather gods decide to dish out that day. In other words, the marine photographer has to deal with what is, what is likely to be, and what he can do with it. At any given point in time, he will be contending with the wind, which will be either increasing or

decreasing, veering or backing; the sun, which is either getting stronger or weaker, rising or setting; the clouds, which are building or dissipating but moving in any case; and be dealing with the water, which is in a constant state of real or apparent change in response to everything else.

Into this changing environment, we must now insert that which is to be photographed, a boat, a group of boats, or what have you.

Out of all this, the photographer must visualize what can be and ought to be done and proceed to either (a) execute it as promptly as possible in case the whole mess falls apart before his very eyes, (b) wait awhile until things get better, or (c) fold up his Brownie and go home and shoot another day.

If he elects to go ahead and get what he can (and this is often the best plan because things may get worse, but if they get better he can always reshoot), he must start, assuming he is after a

Red Snapper, *although hardly an answer to a maiden's prayer as a boat, is nearly ideal as a photo platform. This is not surprising since that is what she was designed and built to be. Very maneuverable and fast enough, she keeps the sea well and offers a variety of shooting positions, both high and low. (Rollei, Plus-X, 1/500 at f/11. No filter since any hot-colored filter would lighten her red topsides too much.)*

simple portrait of a sailboat, with a full and possibly time-consuming study of from what angle the boat looks best.

With that idea paramount, he must also consider the direction of the light and how that affects the boat's appearance and the appearance of the final photo. In addition, he must keep in mind trying to make the clouds complement the whole, and finally, he must decide if what he has worked out will make a great, a good, an acceptable, or a lousy photograph. Answering that question is what separates the men from the boys.

After making that statement though, it is only fair to point out that the main difference between professional photographers and amateurs (according to one wag) is the amount of film they use. The professional will use far more and, in the situation described above, would not even answer the question delineated. He'd take the shot and set about seeing how he could do better. He'd try, if the job were important, everything he could think of and quit only when the subject was well and truly beaten into the ground. Those who think of photography as a nonart should be aware that, whereas a painter can control his composition step by step, revising and altering as he sees fit, the photographer can revise and alter only by taking more and more photos, each one a refinement and maybe an improvement on the previous ones. No professional in his right mind ever takes *one* photo of anything.

All of this makes shooting photographs on the water sound like a lot of work. Well, it is, and if a person is about to set out to take good photographs of boats—or anything else for that matter—he might as well reconcile himself to the truth that the pursuit of any art form *is* work. In fact, since considerable physical activity is involved, marine photography involves the expenditure of more energy than most arts, such as the sedentary pleasure of painting or tootling on a flute.

This is not to say that the work is unrewarding and, to me at least, the source of considerable satisfaction, but it is to say that everything written or shown in this book presupposes the will

to expend the requisite energy. But, time and energy aren't enough, nor is the possession of a good camera. All these things are essential, true, but none will do much good if you cannot physically get in the right place to shoot from. The importance of having decent boats from which to work can hardly be overstated; however, it is rarely considered enough by those who say, "Gee, I wish I could take pictures like that," since a large portion of "pictures like that" is merely being in the right place at the right time.

On this page, I have taken the liberty of showing my magazine's photo boat, *Red Snapper*. She was designed from the keel up to specifically take photographs, and therefore incorporates most of the desirable features that a photo boat ought to have. In the first place, she offers a variety of shooting angles from very low to moderately high. Secondly, she is very maneuverable and offers no wash at slow speeds. Conversely, she will cruise at better than twenty knots to get to where the action is—and to keep up with the vast majority of boats to be shot. Finally, she is seaworthy enough to handle most weather conditions and she has very minimal accommodations to alleviate the inevitable logistics problem on a longer assignment.

Snapper, of course, represents an extreme. No individual will probably go to the trouble and expense of a boat like this, but she illustrates what a photo boat ought to be and perhaps provides an indication of how important I feel a good boat is in the acquisition of good photographs on the water. Next to one good camera it is the most important thing a marine photographer can acquire.

But don't let the lack of a specially built custom-designed photo boat dissuade you. In practical fact, you can shoot from anything that will hold you up. You can do the trick from a dinghy or a rubber raft. You can get off on a dock, a piling, a breakwater, a large rock, or another passing boat. You can, if you have a waterproof camera, jump overboard with a life jacket and bang away to your heart's content. And you can even do what I did one morning,

which was to perch on a bell buoy in the East River. This, however, I don't recommend. It does bad things to your hearing.

All of which serves to illustrate another truism: Where there is a will, there is usually a way. Not always true, but most often.

Finding a place from which to shoot is one example of this, but there are others, all of which belong to the "Let's make it happen" school of photography. The purist will say that the pure way to take pictures is to work with what there is, but sometimes on the water the necessary ingredients to portray an event or to evoke a particular emotion fail to jell by themselves. At times like this, when all the trees are present but the forest is missing, a certain amount of judicious juggling is indicated if the whole thing isn't going to be lost. In fact, I'll go further: Sometimes scenes have to be constructed from the ground up. The trick, of course, is to compose all the elements so that the end result is natural and expresses what you set out to express.

And that is the basic name of the game. Anyone can take snapshots and go home with a fuzzy picture of the good ship *Sally Ann,* or an equally blurred print of Mary and Tom and George and Ann on their cruise last summer, and pretty pictures of either the boat or the group aren't very hard to come by either, but to turn the *Sally Ann* into every boat that ever thrust her bow into the sunlit waters of summer, or to conjure up visions of everyone's cruise in the photographs of Mary, Tom, George, and Ann requires every bit of savvy a photographer has. Nor will the right equipment—even perfect conditions—guarantee a great photograph. Great stuff has been done under appalling conditions with really poor equipment, while some of the greatest turkeys of all time have emerged from fine cameras under fine conditions. The photographer's knowledge, skill, and artistic sense are what makes the difference. Only God can give a person the last, but practice and diligence can supply the skill to anyone. I hope the pages that follow will provide the knowledge.

Visualization and Seeing

Most of us never really look at the world around us, and when we do, we certainly don't see it as a camera does. Yet, successful photography of anything depends wholly on a photographer's ability to truly perceive the world around him and to visualize finished photos in terms of the scenes presented to him.

Eighteen different ways to shoot one small group of people aboard one boat during a brief period of time. Although most—but not all—of these photos were staged and formed a part of a magazine feature about the boat, the group of photos nevertheless offers a panorama of a few of the many ways a boat can be shot.

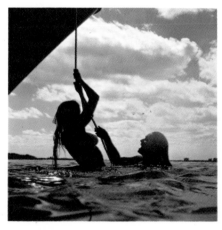

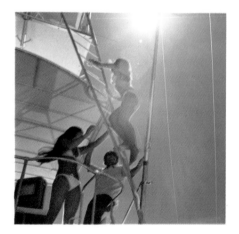

A Guide to Marine Photography

It may seem odd to start a book on how to take photographs here instead of with the basic elements of cameras, films, exposures, and so forth. I could do that, but all that is of lesser importance. If you cannot see, if you cannot visualize, all the technical know-how in the world won't help. There are those who try to overcome their lack of seeing with additional equipment, thinking that somewhere in the gear they accumulate will lie a gizmo that will somehow turn the trick, will somehow come up with the photo they have waited all their lives to take.

They will continue to wait because all the equipment in the world won't replace the miraculous gift of the human eye—provided it is trained.

This training, which is as important to a photographer as doing scales is to a singer, can take many forms. The first is to make every attempt to develop a sense of awareness. Don't just look, but study what you see. This can be done anywhere, and it should be done everywhere.

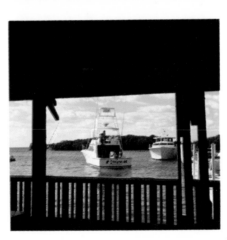

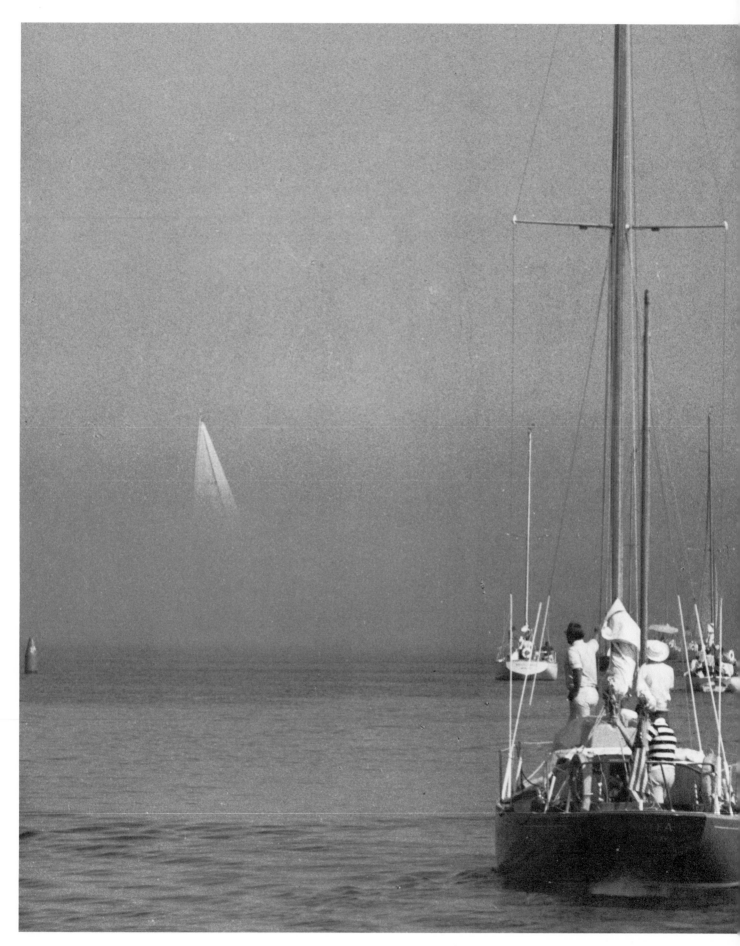

The second form is to study other photographs. Try to uncover what it was that the photographer was after and see if you can discern how he went about it. Try, too, and visualize what the scene must have looked like in reality. To aid you in this regard, on these and the next several pages are a group of photos selected to help you begin to see and to visualize. On pages 10 and 11, for example, there are a large number of photos all taken of the same people aboard the same boat within a very short period of time. The group was originally done to illustrate a story about the boat in question, but the photos will serve very nicely to demonstrate just how many different approaches there are to seeing one boat and one group of people. I recommend the study of these and the photos on the pages that follow.

However, all the study in the world will not replace actual practice. And, to be most meaningful, the practice should revolve around the same object. In other words, take a scene or a thing of your choice and then go study it and photograph it. Burn up a roll or two of film. Process the film and then study the results. After you have determined what is good and bad about them, go do it all over again. You will be amazed how much better the second, third, and fourth times around are.

In selecting the photos for this book, I had occasion to dig through all my stuff, from the earliest onward, and I would be embarrassed to print some of the terrible turkeys of yesteryear. I thought they were good at the time and I guess this is a measure of the progress I have made in the intervening years. I have hopes that the progress will continue, but I don't necessarily want to look back on my efforts here with dismay.

But, be that as it may, perhaps the photos here and my comments about them will serve to help you get started. If they do, they've accomplished their purpose.

To see, to catch the unexpected requires keeping the camera ready and your eyes open. Here are two examples. Left, Bolero's main peeking above a fog bank at Block Island. (Pentax, 200 mm lens, Tri-X.) Right, a boy, his dog, and his boat cruising the ICW on a sunny Florida afternoon. (Rollei, yellow filter, Tri-X, 1/500 at f/16.)

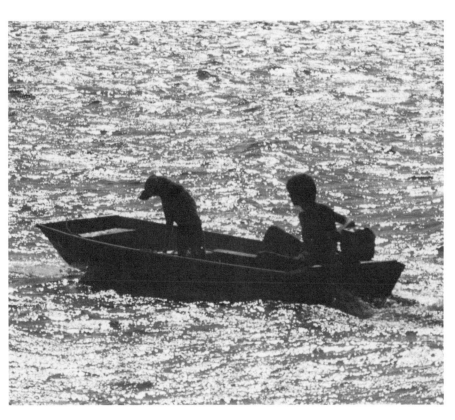

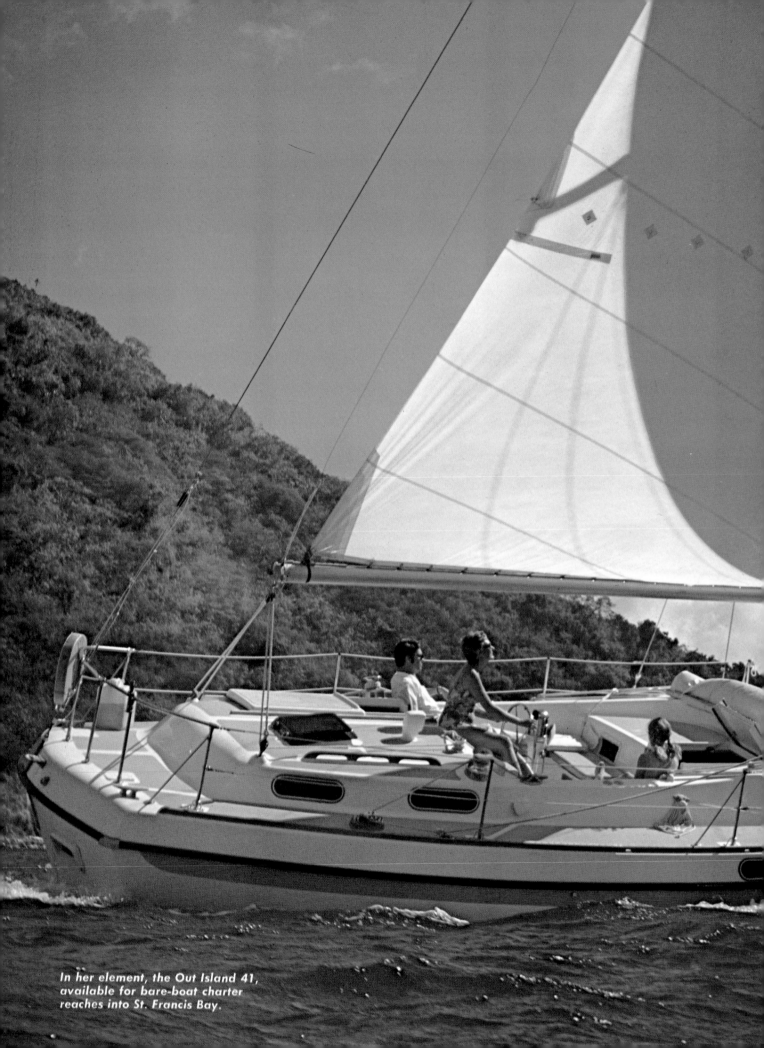

In her element, the Out Island 41,
available for bare-boat charter
reaches into St. Francis Bay.

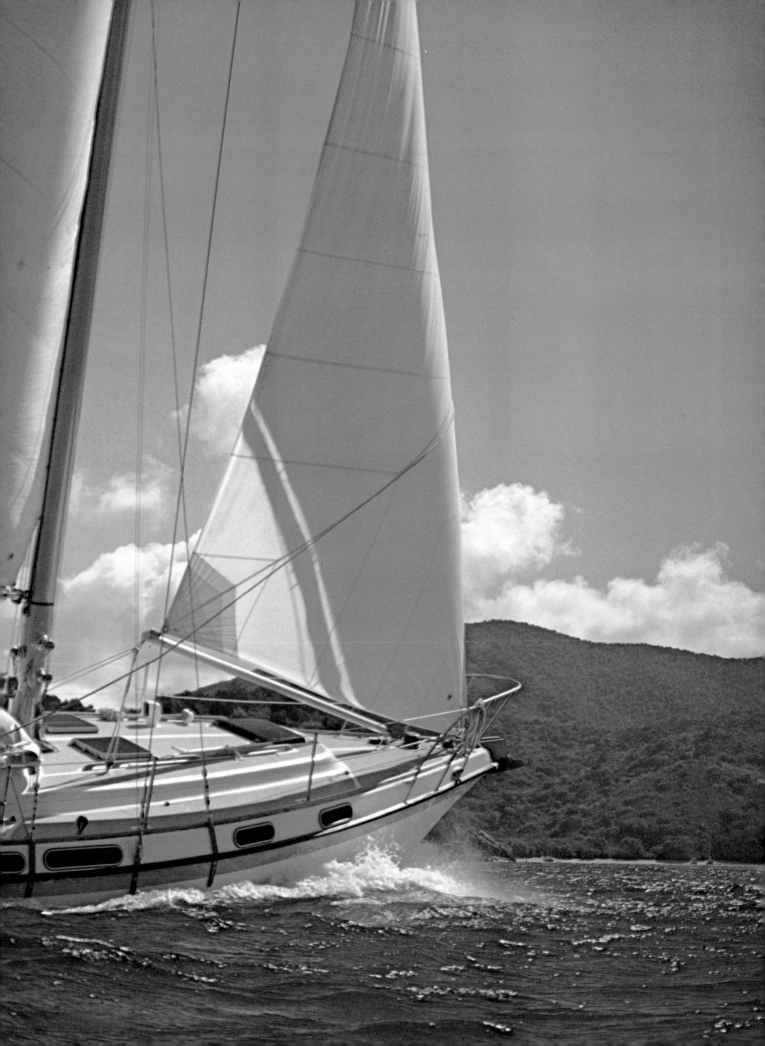

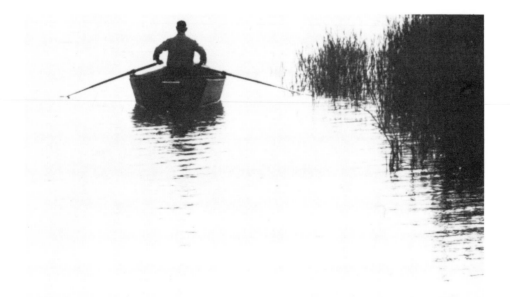

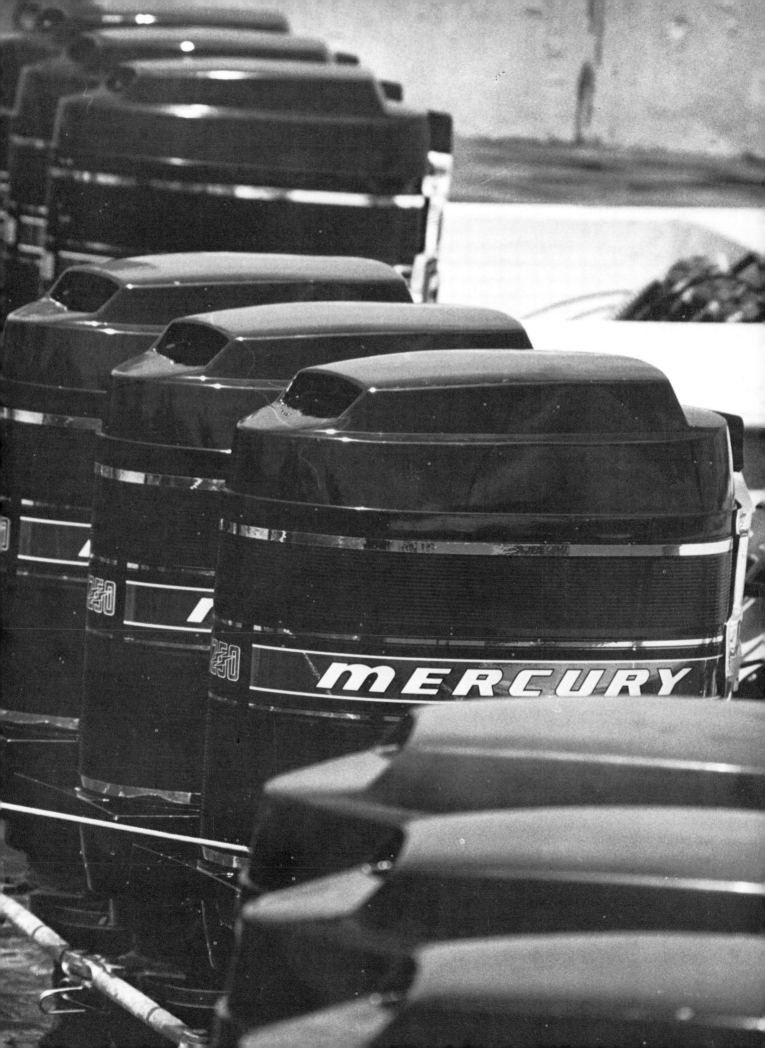

One of the fascinations of the water is its infinite variety of subjects and moods. Surely, the Mako surfing down an angry Gulf Stream sea, and the two young women having a gas at spinnaker flying represent two poles of the boat world. Both are near-water-level photos. (Rollei, Ektachrome; left: 1/250 at f/8; right: 1/250 at f/11.)

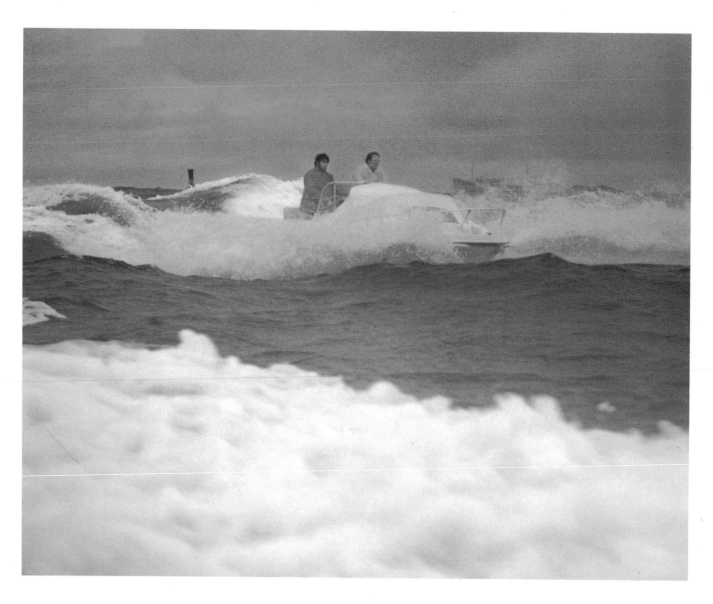

A Guide to Marine Photography

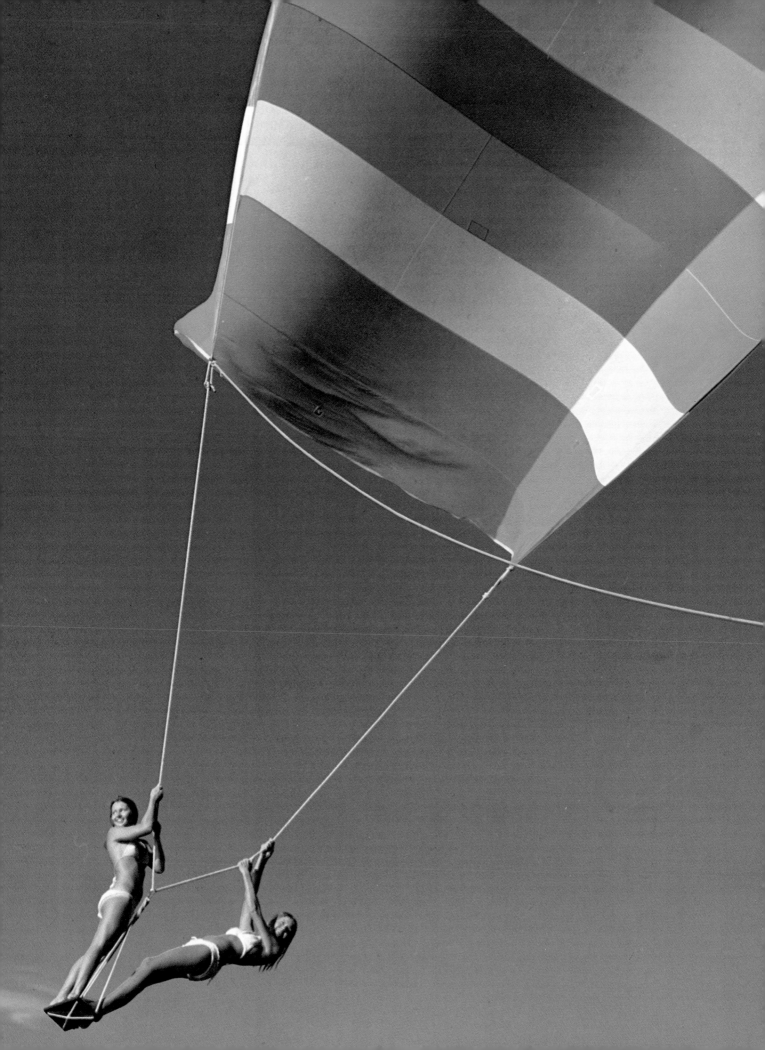

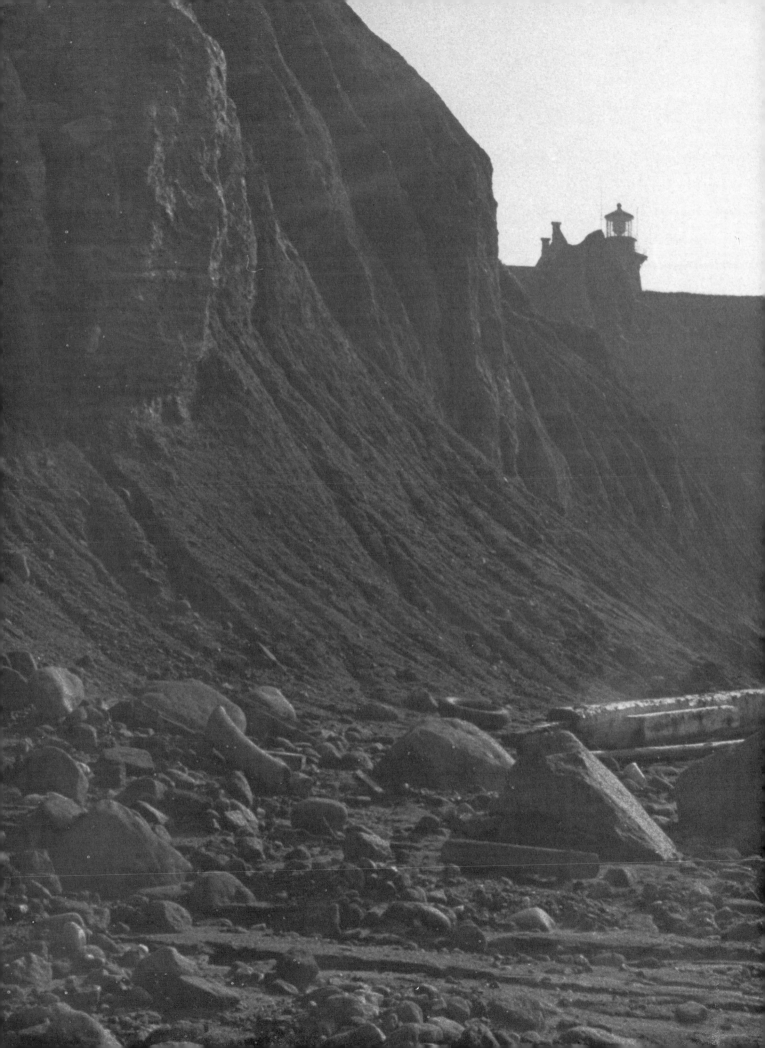

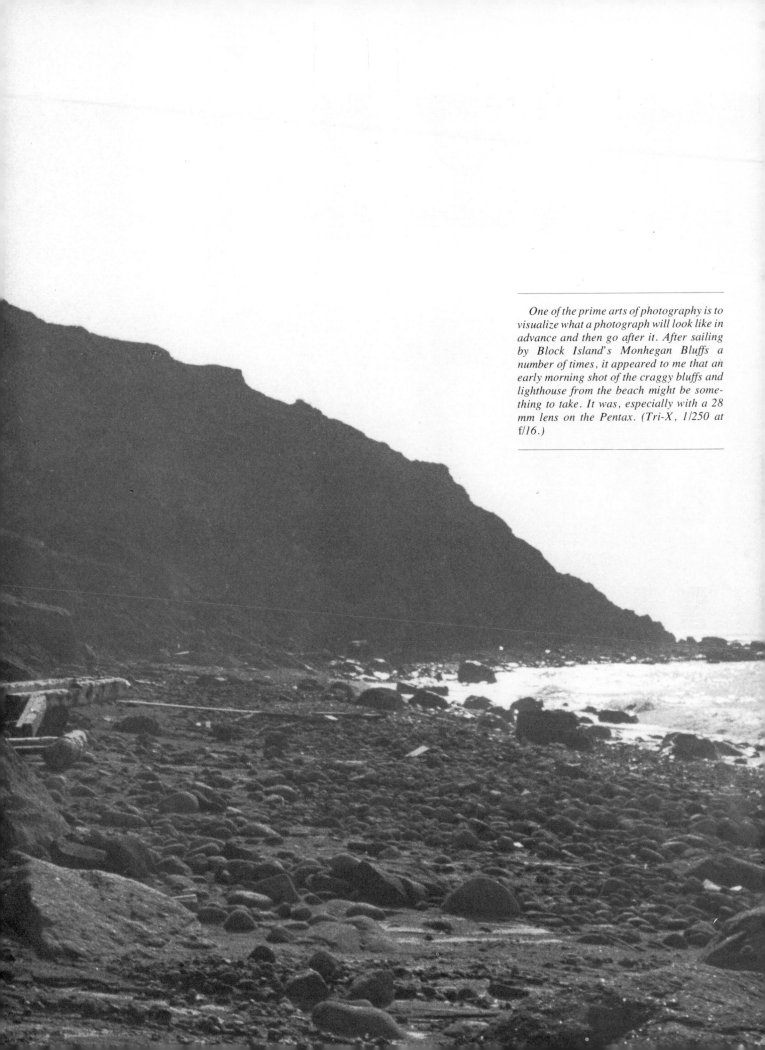

One of the prime arts of photography is to visualize what a photograph will look like in advance and then go after it. After sailing by Block Island's Monhegan Bluffs a number of times, it appeared to me that an early morning shot of the craggy bluffs and lighthouse from the beach might be something to take. It was, especially with a 28 mm lens on the Pentax. (Tri-X, 1/250 at f/16.)

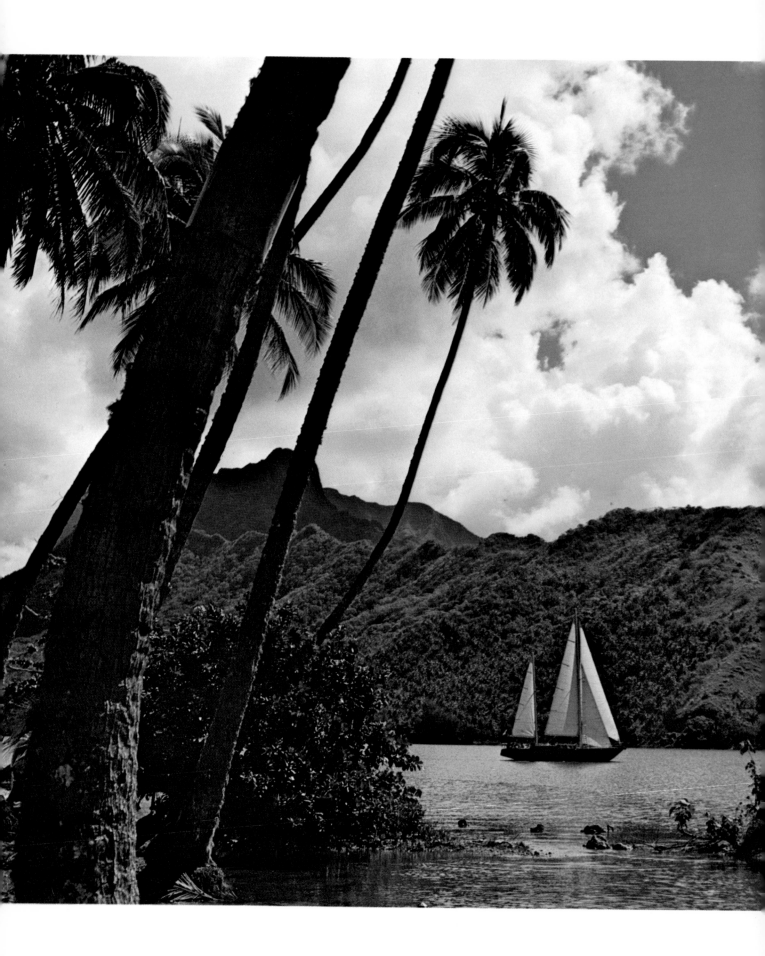

A Guide to Marine Photography

Another example of visualizing and then executing is this shot of a charter ketch in Raiatéa. I saw the palms from the boat, went ashore, and used them to frame the boat as she slipped over the calm lagoon. (Rollei, Ektachrome, 1/250 at f/11.)

Visualization and Seeing

More unexpectedisms: A Donzi races by on Biscayne Bay, left. Above, a six-year-old courtship blossoms at Clinton, Conn. Right, Impromptu foul-weather gear at Miami's Dinner key. Below, a cygnet hitches a ride with Mommy. (Left and above, Rollei, Plus-X; right, Pentax, Tri-X; below, Yashica, Verichrome.)

Sunset at Placida, Florida. The camera was a Rollei, the film Ektachrome, but I would be hesitant about the exposure. At times like this, when the light changes as you look, and with scenes like this where the meter readings will vary extensively with a small shift in the direction in which it is being held, it is better, I believe, to use the meter only to determine which ballpark the correct exposure must be in and then bracket upward and downward several stops. Also, at low light levels, if there is much motion, taking several exposures is mandatory to give you any chance at all of having one sharp picture. The exposure here was about 1/60 at f/8.

The Nuts and Bolts of Shooting on Water

Camera Selection

First, a dogma: Any camera will take perfectly good pictures on the water. However, some of them will take a wider variety than others. Quite logically, the camera with the widest range of adjustable features will be the most versatile. Yet, versatility means complexity, and complexity is usually bad news for the beginner at anything. With gear that is too complex, the neophyte photographer may well find himself trying to figure out what setting to set which lens at while the picture he is trying to take falls apart as he watches it. For this reason alone, I can't recommend strongly enough that a beginner start with a single camera and a single lens (although if he feels that photography is really going to claim his attention, he'd do well to buy a camera to which more lenses can be added later).

However, there are other reasons why simple equipment is preferred on the water. In the first place, since virtually all marine photography is out of doors in the daytime, a very limited range of shutter speeds and aperture openings will cover most every need. Only dawn and sunset require anything very slow and it is a rare adjustable camera indeed that doesn't have slow enough shutter speeds to handle these. At all other times, shutter speeds of 1/125 of a second and faster and apertures of $f/5.6$ and up will handle almost anything that can conceivably come along. There is no need for super-fast lenses, although shutter speeds up to 1/1000 of a second are a real boon to freeze fast action. (I must note that I've survived with nothing faster than 1/500.)

Secondly, shooting on the water is really hard on cameras. Humidity (if not outright water) and salt, combined with the rough and tumble of shooting from fast-moving boats conspire to demolish the staunchist of machines. Since simple machinery is usually less finicky than complex, sensitive equipment, it is to be preferred on the water. This is one reason I hang in with Rolleiflexes. They will take an amazing amount of bad treatment.

This is not to say that any camera should be exposed to one bit more of the elements than absolutely necessary. On the contrary, every effort should be made to keep photo gear dry and safe. It will get wet enough anyway. Some ideas that will forestall the inevitable trip to the camera hospital are:

Keep a filter in place at all times on the lens, at least all the time the camera isn't packed away. This will help considerably at keeping salt water off the lens.

If there is any spray coming aboard, wear a foul-weather jacket and keep the camera under it until the instant you need it. If things are bad enough, you can ask some long-suffering crewman to stand to windward of you when you have to shoot.

Keep exposed color film in the little containers supplied. The film will stay dry no matter what. Rolls that don't have containers can be wrapped up in Baggies. As a matter of fact, you can keep your camera in a plastic bag, too. In fact, there are those that say you can shoot right through the bag if you stretch it tight. I've never tried that.

If you do get salt water on your lens (and you will) remember that you need fresh water to clean the lens. Wiping off the salt water will merely leave a mucky film.

These suggestions, plus whatever you can dream up will help, but I am afraid that the mortality rate for cameras on the water is high. And almost worse than packing up altogether is the nasty habit cameras have of slowing up as their innards become clogged with salt. After a while on the water, the shutter speed you set may not be the shutter speed you get. Any good camera repair shop can calibrate your shutter and supply you with a table of exactly how fast your shutter is actually opening. By knowing that the 1/250 setting actually produces 1/180, you can close up half a step to compensate.

At this point, it would seem appropriate to look at the various kinds of cameras and comment on their usefulness, or lack thereof, in marine service.

Instamatic Cameras

Avid photo buffs will probably cringe when I state that you can take perfectly adequate photographs with an Instamatic, but the truth is that you can do a creditable job with them *provided* the stringent limitations of their usefulness are kept in mind.

The manufacturers of these cameras have done a superior job at selecting a shutter speed (around 1/60 of a second), an aperture opening (about $f/11$), and a moderately wide-angled lens that will produce well-exposed photos at Aunt Tillie's backyard barbecue if it is a bit overcast, somewhat overexposed photos of little Henry's toy sailboat at the beach on a bright day, and more or less underexposed photos of cousin George in front of the Washington Monument at dusk. All will fall within the general realm of acceptability provided—and only provided—you follow the basic rule of Instamatic

photography (my rule) of holding the camera down on something solid. Instamatic shutters are simply too slow to insure sharpness when hand held.

More advanced Instamatics have variable apertures, some of which are automatically controlled by a built-in light meter. These, of course, will take a much wider range of properly exposed photos, but a fixed, slow shutter will still require a firm shooting location. The most expensive Instamatics will have a choice of shutter speeds, too, thus eliminating the problem of camera motion, and in truth these advanced cameras suffer only one major drawback—the lack of interchangeable lenses. This feature is the main stock in trade of the next group of cameras, the 35 mm cameras.

35 mm Cameras

By far, the most popular camera around today for almost everyone from the devoted amateur up is the 35 mm single-lens reflex camera. It is simple and quick to load and unload, fast to operate, light to carry, and in its more expensive version, extremely versatile. It is not, contrary to popular opinion, perfect. It has, to my mind, three drawbacks. First, every photo it takes has to be either a vertical or horizontal photo. Secondly, it produces only small negatives or transparencies. Thirdly, it produces only eye-level photos (otherwise, how could you see through the camera?).

You can spend almost any amount of money that you might care to on a 35 mm camera. (You can even buy some that you can change from eye-level viewing to looking down into.) You can buy manual ones and automatic ones, rangefinder types, and ground-glass focusing types. There are much better references to camera selection than would be appropriate here, so I will not comment further except to underline again that marine service is harder on cameras than almost any other. Durability (which implies simplicity) is more important than adaptability or exquisiteness of construction.

For example, the Nikonos—a camera developed for underwater but useful elsewhere too—has little adaptability (only two lenses are available for it) and is a bit of a pain since the focus has no rangefinder or ground glass or anything. The range is determined by eye and then cranked by hand. Yet it makes an excellent marine camera since it is indeed durable and waterproof. No camera will do everything, though, and most everyone I know who is in to marine photography has at least one normal 35 mm camera. Most have more than one, not only to shoot both color and black and white, but to have a spare at hand in case one packs up —which it will.

For those who are interested, I have a Pentax with 200, 135, 55, and 28 mm lenses.

2¼ Cameras

I must admit to being a Rolleiflex freak. I'm on my third and so far I can see no reason to change. It has the severe limitation of having no lens changeability but thus far this hasn't proved too large a handicap (particularly with the Pentax at hand).

2 1/4 cameras are expensive to buy and even more so to operate. However, even with its one lens, it is very adaptable. For example, it can be used in any position within arm's reach, and its 80 mm lens (which exposes 120 film 2 1/4 inches wide and high) provides a very interesting combination of a mild telephoto effect in the center of the picture and a mildly wide-angled effect if the whole frame is used. In addition, the resulting transparency or negative is roughly four times the size of a 35 mm photo, which means that much less enlargement. Finally, the photo that emerges is square; it can be cropped into a tremendous number of different photographs.

Some 2 1/4 cameras do have interchangeable lenses, and some are of the single-lens reflex persuasion. Rollei makes one, Hasselblad makes perhaps the most famous, and several others are available. All vary from expensive to ridiculous but whoever said anything good was cheap? Once again, remember that the marine world is rough on delicate equipment, and selection should be based as much on durability as on anything else. A broken camera is no good to anyone.

An opposite approach worth mentioning before leaving the subject of cameras is to use cheap ones and throw them away when they pack up. The Yashica line (particularly the 2 1/4 models I'm most familiar with) has cameras that will take fine photos and are quite inexpensive. I used to use one and found that at high f-stops, say f/11 or f/16, their sharpness was fine. I've often wondered since I've gone high class whether or not it would be better to use a Yashica on board for as long as it would last and then get another. Rollei repairs aren't free. Thank God there aren't too many of them.

Shooting Afloat

There are two great pitfalls in marine photography that I will mention here, and will undoubtedly bring up again and again as the book proceeds. They are motion and exposure.

Motion—As anyone who has ever been on a boat knows, there is always motion on the water. It may vary from a slow roll over a lazy swell to a gut-stopping crunch into a head sea, but there is always motion, and for this reason boats make terrible shooting platforms. Yet they are a necessary evil, one that can only be coped with by high shutter speeds, speeds that get higher as lens length increases. Except for special purposes, I wouldn't shoot at less than 1/125 of a second with a normal lens, nor would I attempt less than 1/500 with a telephoto. To do so is to risk blurry photos.

Sometimes you must deviate from these minimums, as we will discuss later, but if you do, you had best be prepared to shoot up a storm in the hopes of getting one sharp picture out of a great number of fuzzy ones.

Exposure—Truly more marine photos fail from overexposure than any other single cause. The light meters will routinely serve up readings which result in photos that—in my experience—are somewhere between one and two stops overexposed. This, of course, only applies to bright, sunny

days, but that is when the vast majority of watery photos are taken and I think the reason for it is the great amount of light that reflects from every surface, reflections that meters somehow miss but cameras don't.

As a result, I have fallen into the routine of automatically reducing every reading by one stop at least, or simply dispensing with the meter and going on prior knowledge, which often tells me that setting a camera for 1/250 at *f*/11 will produce something useful with Ektachrome film (again, assuming it is a bright, sunny day). Additionally, the side of righteousness in bracketing is less exposure, not more. If there are any secrets to marine photography, this is surely one of them.

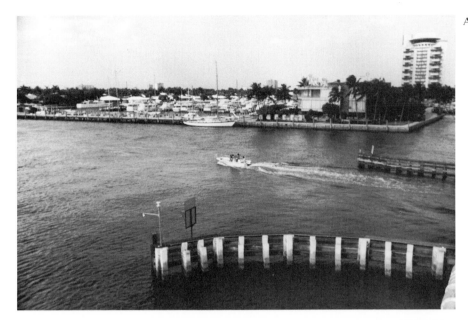

<div style="text-align:right">A</div>

<div style="text-align:right">B</div>

Lenses

There are two important things to remember about lenses. The first is that a lens of a certain focal length will produce an image of a certain size on the film quite irrespective of the camera the lens is attached to. Thus, an 80 mm lens on a 35 mm camera will produce exactly the same image as a 80 mm lens installed on a 2 1/4, or on an 8 x 10 camera for that matter.

The second thing is that, as the photos on this page illustrate, the focal length of a lens has nothing to do with the relative sizes of the objects in a photo. Perspective does not change. All a longer lens does is enlarge the objects and a section cropped from a photo taken with a short lens will be identical to a larger section cropped from a photo taken with a longer lens.

The point of all this is to illustrate that a mobile shooting platform which can be moved closer or farther from the subject can go a long way toward eliminating the need for an overly complicated camera kit.

This is not to say that some lenses aren't necessary if all the photographic opportunities of the water are to be exploited. There is, for example, no way to do terribly much with onboard cruise pictures without a wide-angle lens. The only way to get the full sweep of most cockpits without such a lens is to shoot from twenty feet left of the port rail, a stunt that is often difficult to perform.

Nor is there any way to cope with a great range of scenic subjects without some kind of telephoto. Normal lenses on 35 mm cameras have a distressing tendency to turn interesting shore lines into skinny, featureless blurs.

In order of importance, I would acquire a normal 55 mm lens (this most often comes with the camera) and then a 28 mm or 35 mm lens. The next addition would be in the 135 mm range, followed by a 200 mm. I don't think I'd mess with anything longer than 200 mm.

As with genoa sizes, a lot of lens selection will rest firmly on opinion and personal taste, so do not accept my recommendations as dictums. Whether you follow my ideas or form your own, though, do go slowly in acquiring lenses. Learn what each one will do, explore the limits of possibility with each one before going on to the next. To get them all at once will merely make life confusing, as when the neophyte sailor starts out with a boat fully equipped with every go-fast in the book and spends all his time misadjusting the wrong string. As he would be better off contending only with a sheet, so would the budding lensman be miles ahead with but one lens for openers.

A. 28 mm

B. 55 mm

C. 80 mm

D. 135 mm

E. 200 mm

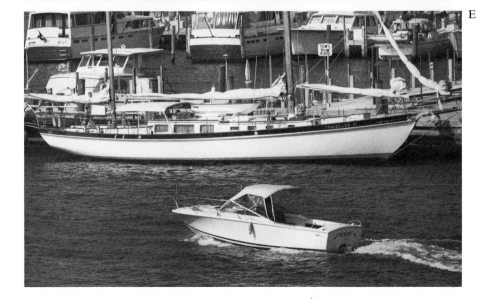

No Filter

Orange Filter

Yellow Filter

Red Filter

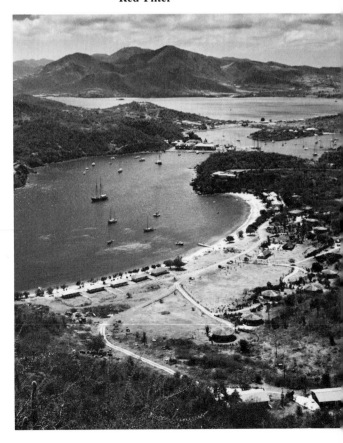

Black-and-White Films

In this day and age of a color-oriented mass photographic market, it probably seems odd to spend much time or space on black-and-white films and photography. Yet, it has been my experience to note that virtually all serious photographers—amateur and professional alike—will almost invariably shoot black and white when they are shooting for their own pleasure (i.e., to create a work of art).

There are two reasons for this, one artistic and one economic. The economic one is simply that shooting black and white is cheaper. The processing can be done easily and a considerable number of prints can be made and discarded without running up too large an investment in a single finished product. The artistic aspect is related in that, since processing can be done by the photographer, he can exert total creative control over the photo from original exposure to finished print. And that is important, since taking the photo in the first place is maybe a third, maybe a half, of the total creative effort. Developing can make or break the negative, and in printing, a photographer has as much leeway for success or error as he had in shooting the photo, maybe even more.

Of course, not everyone is interested or equipped to do film developing or printing, nor is it appropriate here to become immersed in the various techniques and types of equipment necessary. There are many excellent photo books available that will take you by the hand and show you the ins and outs if you should care to partake of darkroom work. It is, however, appropriate to point out that processing and printing are as important as taking the photo. Hence, black-and-white film should never be sent to the corner drugstore for processing, nor should it be sent to any mass production photo finishing service. They will both cheerfully and carefully ruin the best. If you care enough about your photos to have taken them in the first place, you should have them done up by any one of the great many custom photo processing houses that can be found in any large city. The Yellow Pages lists them, your local camera store knows them.

When I don't do my own processing, which is most of the time, I send it to the lab run by John R. Kennedy at 211 East Thirty-eighth Street in New York City. John has done my stuff for years (including most of the prints in this book). Although he does a great deal of commercial work, his first love is working with individual photographers.

When I do my own, I will almost invariably use Kodak D-76 developer mixed half and half with water. This works well with the Plus-X film I'm also hung up on. I went through a Tri-X phase, but I was never able to achieve a satisfactory grain structure with consistency. Tri-X will work satisfactorily at higher latitudes where the sun lacks tropic intensity but it is really a bit much in the islands. Panatomic-X film is one I've never had much luck with because its speed is marginal for marine work. They say its grain is even better than Plus-X but since I can make wall-sized blowups from the Plus-X negatives, why bother?

That is my method and my choice of film. However, I must state fairly strongly that that is but one of many roads that lead to the same destination: a good print. Just as two good sailors will tune their boats entirely differently, so will two photographers use different films, different exposures, different developing, different printing papers, yet they will both come up with winning photos.

I've heard photographers laud and scorn every kind of film, yet all of them (including the Verichrome that is the standby of the Brownie set) have been and can be used to produce magnificent photographs. In the light of this, what is a beginner to do?

In a sense, it doesn't make too much difference, since all available films and developers will do a better job than he can. The trick, as I see it, is to pick one combination and stay with it until you know what it will and won't do. After that, you can experiment to see if you can find a film/developer combination that suits you better.

There are, however, some standard black-and-white shooting techniques which all photographers more or less agree on. I speak primarily of the use of filters.

Black-and-White Filters

To understand what filters do, we must back up to the film. These days all black-and-white film is panchromatic. That is, the film will record all color equally, without fear or favor, in varying shades of gray. A filter on the other hand discriminates between its own color (which it allows to pass freely) and its complementary color (which it blocks). Yellow blocks purple, orange blocks blue, and red blocks green. In practice, though, all hot-colored filters block all cold colors to a lesser or larger degree. Since the water and sky are primarily cold colors it follows that the use of a red, orange, or yellow filter ought to deepen the sky and the water, which is precisely what happens. A yellow filter will darken the sea and sky some, an orange one will darken them more so, and a red filter will make them almost black. I know of no one doing black-and-white photography on the water who does not have a collection of these filters. I cannot imagine shooting without one of them—except, of course, when I'm after a flat, no-definition picture.

All filters block some of the light entering the camera. The amount they block is referred to as the filter factor and has to be taken into account when setting light meters that do not view through the lens. The latter variety, of course, will see what the film will see and respond accordingly.

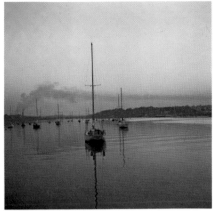
Dawn

Hopetown light, sunset

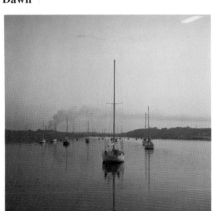
Sunrise

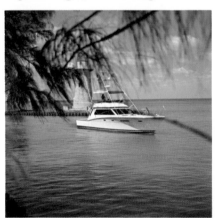
Hopetown light, midmorning

Noon **Dusk**

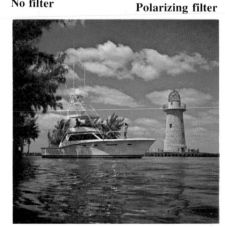
No filter **Polarizing filter**

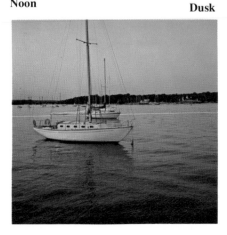

Color Films

Color photography has both its virtues and its limitations. Its virtue is its color, its limitations are those of creative control. Most normally, color processing is beyond the reach of most amateurs (and most professionals) and even if a person elects to go through the lengthy process of developing his own color, there is little he can do to alter the final result. Color processing is a real go-by-the-numbers routine.

Color printing does, of course, present some creative possibilities, but the details of the various methods are far beyond the scope of this book. Those who wish to get into color printing (and color processing) are referred to their local camera store.

Color film falls into two prime categories: negative and positive films.

Color Negative Films

Color negative films all have the word "color" in the brand name, for example, Ektacolor, Kodacolor, and all produce a color negative which, according to the great white father in Rochester who makes the little yellow boxes, can be used to make color prints, color slides, or black-and-white photos. While it is true that all three can be obtained from a negative, the slides aren't as good as those made from positive film nor are the black and whites the equal of prints made from black-and-white negatives. The color prints are good, but even here I'd question their quality as compared to a first quality print made from a Kodachrome slide. However, if color prints are your

main interest, then these films should be in your camera bag.

Color Positive Films

Positive films are those that produce slides or, more correctly, transparencies. They all have the word "chrome" in the name, for example, Kodachrome, and in using all of them, the film that is exposed is the film that ends up chopped up into slides. Since there are no intermediate materials, it stands to reason the quality is better.

As a matter of fact, it is Kodachrome that is the standard against which the grain structure is judged. It is the measure that all others fall short of and it is no wonder that the *National Geographic* uses it for most of its photographs.

It is, unfortunately, only available in the 35 mm size. Those of us shooting with larger cameras must make do with Ektachrome, which does have some grain and an unfortunate tendency to pick up all the blue there is to pick up, whereas Kodachrome will salvage whatever warm colors there are around. In normal sunlight this doesn't mean too much, but on hazy or overcast days Ektachrome photos will be considerably bluer/grayer than the equivalent in Kodachrome.

However, as with many other areas in photography, the selection of color film will be a matter of opinion more than anything else. While most people stay with Kodak's products, others will routinely use Agfa, Ansco, or Fuji. I personally have a strong bias toward Kodak, mostly because I hate surprises and I have yet to be surprised by a roll of Kodak film. Further, the stuff is readily available everywhere and just as easily processed. That's my feeling, but that is not to even infer that you shouldn't try them all. In fact, you should before deciding which you like best.

Color Filters

There is only one filter that I have found useful for color work and that is the polarizing filter. As the name implies it acts in essence as a sunglass for your camera, knocking down reflections and so forth.

All polarizing filters are mounted in a turntable ring which mounts on the camera. When you have composed your photo as you'd like, you then turn the filter to maximize the polarizing effect (or to adjust it to suit your artistic fancy). Each different direction will require a readjustment of the filter, and the filter itself varies in effectiveness in relation to the sun. When shooting down-sun, the filter will have little effect. Shooting at right angles to the sun will maximize its effect.

The main effect is, by reducing reflections and glare, to deepen the color of the sky and the water and generally tend to make all colors more saturated. At its maximum it will make a photo look almost garish and is therefore not everyone's thing. It will, however, at times save a picture that otherwise might have been a drab, blah nothing. Every serious marine photographer should have one.

There are other filters usable for color work such as the ultraviolet filter and the haze filter but I have had little experience with them, nor have I seen anything which makes me think I've missed something.

Color of Light

I guess that everyone knows that the light from the sun varies in color during the day, but until one gets into photography, I doubt anyone realizes just how much it changes. This is more than an apparent change, it is a real change in color, shifting the appearance of everything from pink in the morning to blue around noon and orange and red at dusk. For your edification on these pages I have a set of photographs taken over the course of a single day. The camera purposely was aimed north to minimize the effects of the sun and to concentrate purely on the quality and color of the light. A study of this set of photos will tell you all you need to know about sunlight and its color.

Color Exposures

As any beginner at photography knows, the exposure of color film is far more critical than that of black-and-white film, mostly because what you shoot is what you get. You have no second step of printing to compensate for errors.

As mentioned earlier, overexposure is the nemesis of the marine photographer and nowhere will it show up more than in shooting color. And an overexposed color picture is truly blah, whereas a technically underexposed one can be richer and more color saturated than the real scene.

Procedurally, I would recommend (at least for openers) shooting one stop below meter readings and then bracket up and down a single stop. If you feel like it, bracketing down an additional stop might well prove interesting, too.

Sun Angle: Quality of Light

I almost labeled this section "The Sun Is My Undoing." That is too corn-ball for words but it does serve to emphasize the importance of the sun and from whence it shines—and how it shines as well.

Although there is every degree in between, it is simpler to consider sunlight in terms of high and low angle; front, side, and back light; clear and hazy.

Most professionals, particularly when doing catalog or advertising work of boats prefer to shoot early and late in the day when the sun is low. Early and late sunlight is warmer than midday sun, while a high sun will make for harder, more pronounced shadows. A photo in a bright overhead sun will be so bright as to be almost harsh. For some photos (see pages 14, 58, 86) this brightness is essential. For others, such as people pictures, a high angle is usually disastrous.

The height of the sun will determine how much sparkle there is on the water, since sunlight is reflected from the surface at the same angle it strikes the surface. If the sun is high, the camera must also be high if there is to be maximum sparkle.

However, it is only back-lit photos that sparkle. You must be shooting toward the sun to have the water glint and glitter and for this reason alone a great number of photographs on the water are taken toward the sun in a rather total negation of the old dictum of having the sun over your left shoulder when shooting. Morris Rosenfeld, certainly one of the greatest marine photographers that ever existed, often back-lit his photos and then saved the details of the camera side of the boat being portrayed by artful dodging.

This points up the biggest problem of backlighting: the near side of the object being photographed is in shadow. I don't ordinarily find this objectionable. Rosenfeld obviously did. You can take your choice.

Side lighting is most useful in defining shape, such as the sweeping curves of a sail, or texture. Water will lack sparkle when side-lit, but wave shapes will tend to be more defined than with straight front lighting, perhaps the least often used lighting direction on the water. It tends to be flat and uninteresting. A study of the photographs on this page will point this out, as well as the effects provided by sunlight from the three major directions: front, side, and back.

What is not shown in these photos is the effect of haze, certainly one of the marine photographer's biggest bugaboos. Haze does two things. It softens and diffuses the sunlight, and it mutes and even obscures. How much it obscures and mutes is a product of the amount of haze and the distance between subject and camera but it doesn't take much haze or distance for a boat, particularly a light-colored one, to lose definition and character. Haze, like everything else, has its usefulness. It is great for close-up pictures of people and other things that hard shadows would not be complimentary to. Some photos, such as the one on page 76, depend on it for success, but trying to obtain sharp, defined, exciting photos of boats on a hazy day is a fair bit of time wasting.

Columbia, *1958 defender of the America's Cup and contender for the 1962, 1964, and 1967 defenses, displays the effect of front lighting (top left), side lighting (top right), and back lighting (bottom). This series was shot off the coast of southern California. (Rollei, orange filter, Plus-X, 1/250 at f/11.)*

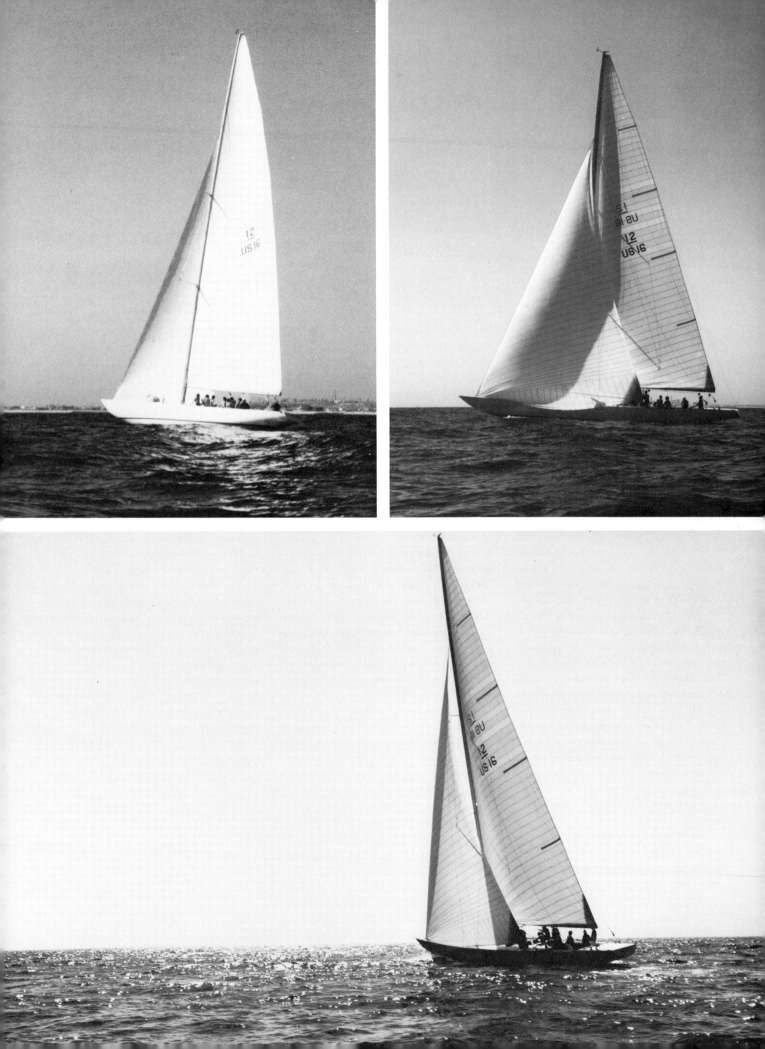

Elements of Composition

So far, we have hopefully opened you up to seeing and visualizing photographs and we have trotted lightly through the nuts and bolts of basic photography. By now you should be primed with ideas and armed with the tools and, at this point, we can begin putting it together into photographs. That is, of course, what composition is all about.

But before I start in with rules and principles, it must be stated in the sternest possible terms that *nothing* about composition, particularly nothing that is stated on the next few pages, is sacrosanct. Sometimes a successful photo breaks every rule in the book and it is undeniably a great picture. For example, the standard format for a photograph is a rectangle having the ratio of 4 to 5. It's most often a pleasing, satisfactory format and will work most of the time. It will not work all of the time and a heads-up photographer, although usually adhering to the norm, will be ready to deviate and produce a square photo; a high, skinny photo; or a low, long photo to express a certain mood or enhance a particular subject. The message is basically clear: when it comes to photographic composition, nothing is sacred.

But there are a number of pretty standard compositional principles that will enhance a photograph most of the time. These are: use of picture area, use of value, use of lines of direction, devices to create the illusion of depth, timing, and focus. The following pages will delineate each of these in detail. All of them serve the same function: to draw the viewer to what the photographer wanted him to see in the way the photographer wanted him to see it.

That is the essence of composition: arranging the elements of a photograph in an interesting and pleasing way so that the important is magnified and the unimportant eliminated. Perhaps one of the most basic flaws common to beginning photographers is the attempt to include too much. Or, to word it another way, the lack of discipline in eliminating the unwanted, the unnecessary, and the confusing. Doing this takes keen observation and the willingness to work just a bit harder. I can clearly remember taking a photo of a very interesting local boat in Saint Thomas only to discover, after processing, that what I had actually done was to take a magnificently dull photo of a seawall with a boat somewhere along its length. It wasn't even a good seawall photo.

Doing this is all too easy. I've taken enough of these turkeys to know just how easy it is to overlook something in the scene that will, in the end result, overshadow and ruin the whole thing. In short, I forgot the basic of any and all photography: A photograph can have only one center of interest and everything else must be clearly subordinate to it. Everything must work toward enhancing that center of interest.

This does not mean, I hasten to point out, that the center of interest needs to be in the center of the photo, nor does it have to be the biggest, brightest, or boldest subject visible. In fact, as a general rule, it should *not* be at the geometric center. If it is, the photo will probably be dull and tend toward the monotonous. Just as the arc of a circle is dull compared to a curve of changing radius, so will a photo benefit from having a center of interest that is displaced left or right and up or down. Somewhere I read that the center of interest ought to be at one of four points, each one a third of the way down or up and a third of the way in. I don't know about that rule, but I do know that having the horizon bisect a page and having the boat smack in the middle is the dullest of all possible ways to take the picture.

And I do know that having more water behind a boat than in front makes me feel that the boat is trapped. She has no water left to sail in. My intellect tells me, of course, that she has all the water in the world, but my eyes—which only see the photo—tell my guts that she doesn't. Putting more open space ahead of a boat automatically gives the photo more freedom, more life.

That is perhaps getting a bit ahead of ourselves. Right now let us turn to the elements of composition and see what we can see.

Early morning in Mystic, Connecticut. A doorway of one of the old seaport buildings served to frame a cat ketch and the schooner Golden Eagle. (Rollei with Tri-X.)

Same basic photo, but three different expressions, due to use of picture area: a close-up spells life aboard; a medium shot offers a portrait of the boat; a long shot speaks of the joy of sailing.

A Guide to Marine Photography

Picture Area

Let the punishment fit the crime, said Messrs. Gilbert and Sullivan. I say let the picture fit the picture.

Earlier in this book I talked about the importance of visualizing a photo and knowing what you were after. What are *you* trying to say about this scene? Is it a photo of people having fun on a boat? Is it a portrait of a boat? Is it a photo of a boat cruising along, alone on a wide, wide sea?

On these two pages, there are three nearly identical photographs, each one illustrating one of these three points of view. The picture in each case is the same, the photograph that results in each case is entirely different.

Perhaps the hardest trick in all photography is to remember continually as you're looking in the viewfinder that the ultimate viewer of the photograph you're about to take will only see that which is bounded by the four sides of the photograph. The area of the photo is all you have to work with. You know what else exists outside of the objects in the viewfinder, what else is going on, and particularly what you

feel about everything that is occurring, but this knowledge has nothing whatever to do with what will appear within the borders of the photo. To put it in other terms, if a viewer has to understand the context in which the photo was taken to understand the photo, then it isn't much of a photo. Just as some accidents are funny when they happen, but are dull and drab when related later, so are some scenes interesting, but *only* interesting in context. A single photograph has no context. It must stand alone, and only the area of the photograph itself counts. Use it in good health.

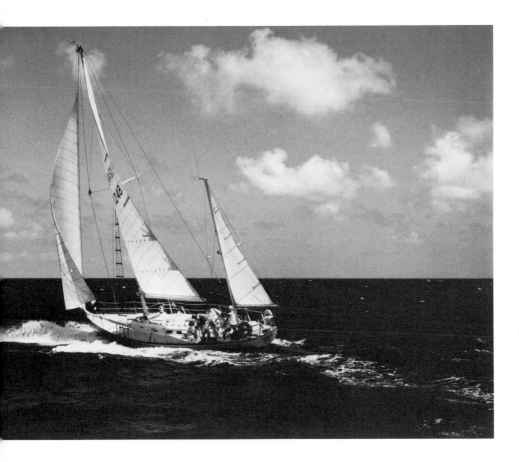

Depth

Depth, as a compositional device, refers to the idea of framing the center of interest by something in the foreground: a branch, a doorway, or what have you.

It serves two purposes. First, it tends to draw the viewer's eye toward what you wish it to be drawn toward. Secondly, it is a way of tying the subject of the photo to a locale, to an event, to a person, or, as in the use of a cruise photo, to the boat the photographer is on. Thus, framing the photo with a palm will suggest the tropics, while shooting another boat through the rigging of your own will turn a photo of a pretty boat into a photo of a pretty boat seen on your cruise.

The photograph on this page, taken at Marco Island, Florida, is one way of framing for depth. There are many others throughout the book.

(Note: Both the Bertram at Marco Island, left, and the Bertram wave jumping in the Stream, right, were taken with a Yashica with yellow filter on Tri-X film. Exposure left was approximately 1/500 at f/16, right was approximately 1/500 at f/8.)

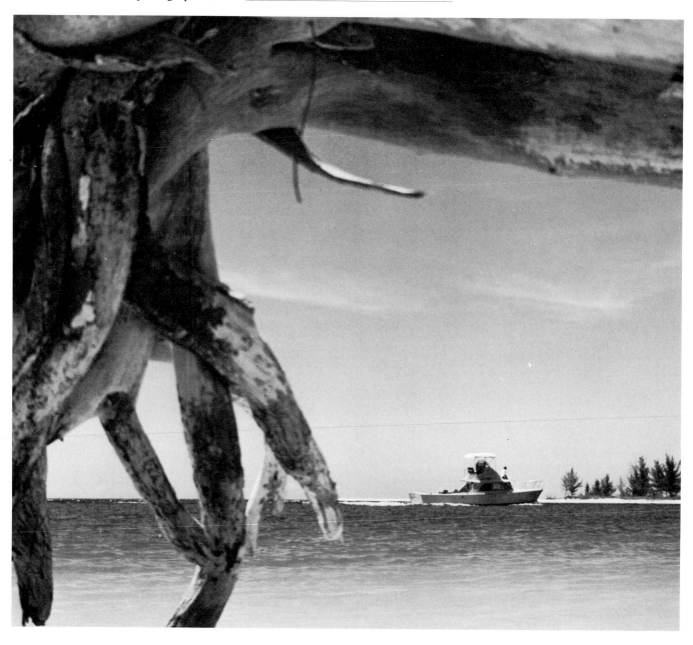

Lines of Direction

Lines of direction are graphic elements within a picture that lead the eye of the viewer down the garden path to where the photographer would like him to look, and see what he would like him to see.

In straight boat photography there is not too much opportunity to use this device, but since it is a valuable compositional technique in many areas of photography I am including it here. Besides, every now and again awareness of the technique will salvage an otherwise useless photo. The shot on this page is a prime example. Without the photo boat's wake, the picture would be a bomb. With it, particularly since the subject boat is jumping it, it makes a picture.

Then too, lines of direction—if you do not take them into account—can detract from a photo as well as enhance it. Each kind of line has its own emotional appeal. Horizontal lines suggest peace and serenity. Vertical lines suggest strength and action, sweeping curves suggest grace and aliveness. As long as these lines are in keeping with what you are trying to portray, fine. But when they aren't, you may find that part of the photo is saying one thing and the rest something else.

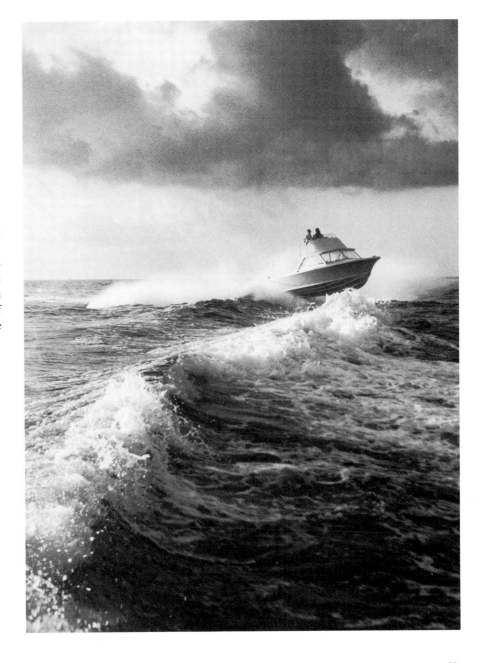

Value

Value, in the photographic sense, means the lightness or darkness of the objects in a photograph. Using this characteristic of the objects can be a valuable compositional tool. On this page is a photograph illustrating the use of value: a white houseboat slipping along a creek through dark woods. The composition of the photo rests squarely on the differential between the subject and the environment it is in. Without this differential the photo would be nothing.

Once again, at this point, I must reiterate the importance of seeing as a camera does, especially if you're shooting black and white. Film will record all colors equally. A varied color scene, if all the colors are nearly the same value, will result in a featureless assemblage of gray on gray on gray.

In color work, too, it is important to keep an eye on the various colors in a photo. Marine scenes are predominantly blue, and since this is so, cold colors will tend to blend in the photos while the hot side of the spectrum will pop out. A spot of hot color in a photo can sometimes save the whole day.

(Note: Photograph, left, of the Drift-R-Cruz houseboat on Connecticut's Selden Creek was done with a Rollei with Tri-X through a yellow filter, 1/250 at f/16. The three sloops right were taken with a Pentax with Tri-X film, 1/500 at f/16.)

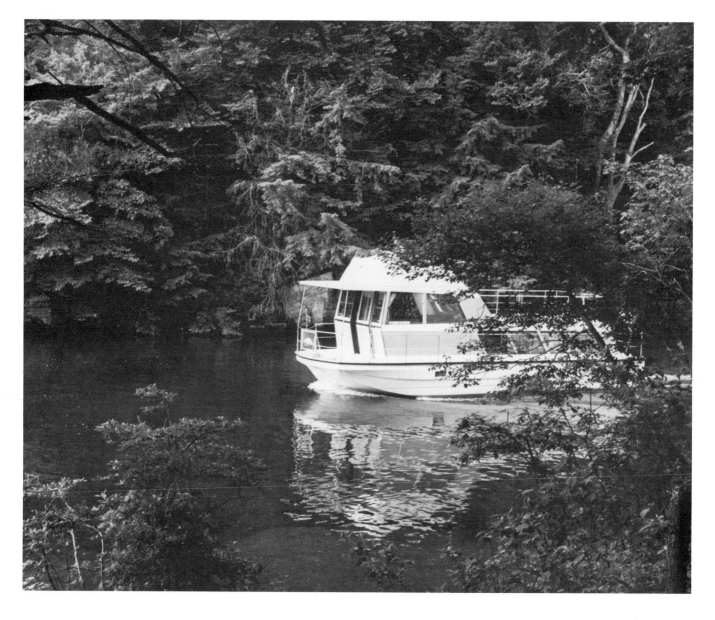

Timing

One of the main things that separates marine work from shoreside photography is that everything on the water is usually in motion. This motion, while it makes life more difficult, also supplies the marine cameraman with one more valuable way of composing photos.

Sometimes, making timing work for you is just a case of keeping the camera aimed until everything falls into place. Other times, it is a case of seeing very clearly what is going on, how each boat or object is progressing, and visualizing each enough to know that when boat A passes tree trunk B, if you stand on rock C, things ought to work out. Sometimes they do, and sometimes they don't.

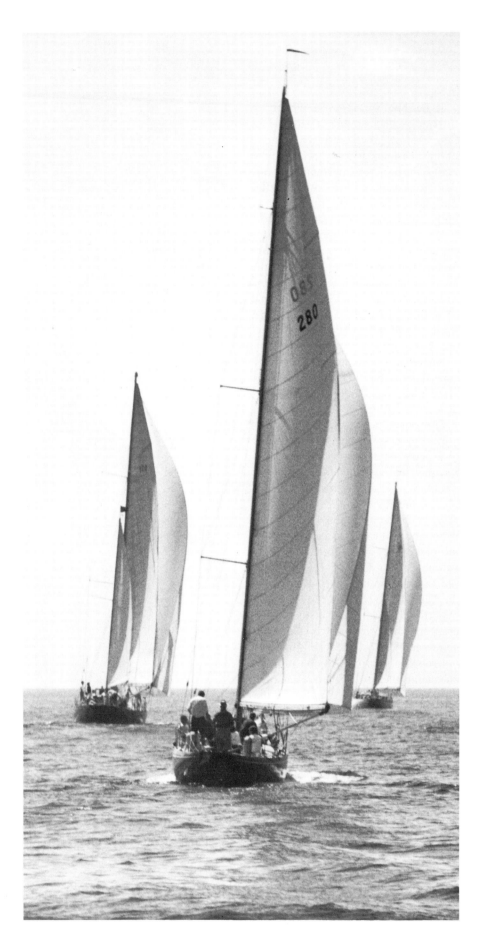

Cropping

It became apparent, in discussing this book with a number of people with little photographic experience, that one of the least understood facets of the craft is the processes and manipulations that are possible and/or desirable after the photo is taken. To many, apparently, the whole photographic process begins and ends with the snapping of the shutter. In actuality, nothing could be further from the truth. Snapping the shutter might amount to a third of the process. Another third lies beforehand in setting up the photo while the final third we will discuss here: what can and should be done after the fact.

Regrettably, we can only touch very superficially on these manipulations since photographic processing is worth at least one whole book by itself.

Obviously, a lot of the more involved processes (e.g., adding clouds to a photo or deleting something distracting or objectionable) are most often not worth the effort, at least at a pleasure level, but no one should get (or stay) in the habit of thinking that there is nothing that can be done to improve the photo after it is taken. There are very few photos in this book, for example, that are shown as they came out of the camera. If nothing else, the vast majority of them have at least been cropped, and cropping is the most common and most necessary process.

Cropping improves composition by enhancing the use of picture area (as discussed on pages 36–37). Rare is the raw negative that is composed exactly right. Once in a while a full negative print will be the best possible one, but normally some of the picture should be eliminated, that is, cropped. How much or how little will depend on the photo and your personal eye but I would look at every negative with a jaundiced eye toward what can be done to enhance it.

For the person shooting black and white and equipped with his own darkroom, cropping is no problem. In fact, he'll routinely crop as he makes his

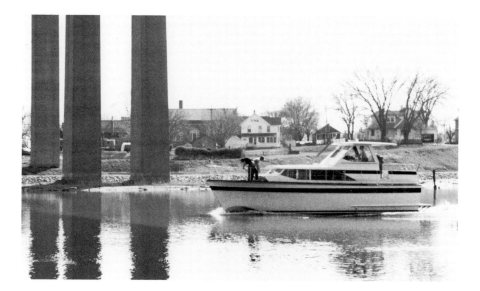

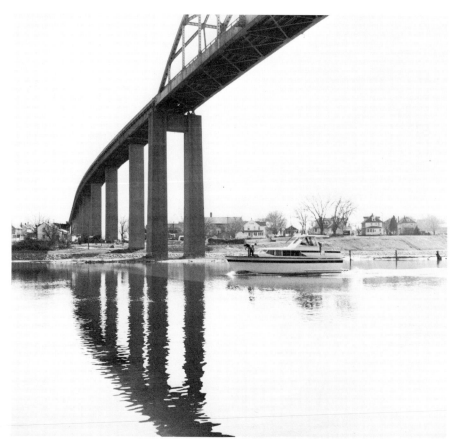

enlargements. For the person without his own setup, and/or who is shooting color, cropping becomes a bit of a problem.

In the beginning at least, the easiest solution is to lay it all on your friendly camera store salesman. I have found, by and large, that most good camera stores are staffed by people who are deep into photography themselves and love to help budding photo types.

All of the photographs on these pages were produced, by cropping, from the one original negative, shown in entirety immediately above. The scene is of a motor yacht passing under a highway bridge on the Chesapeake and Delaware Canal. Note how the whole effect of the photo can be varied by varying the cropping. The most successful cropping, and the one used when it was first published, is shown at the lower right.

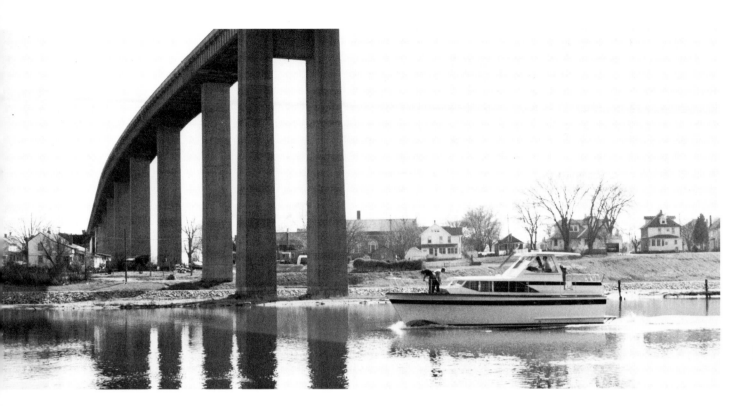

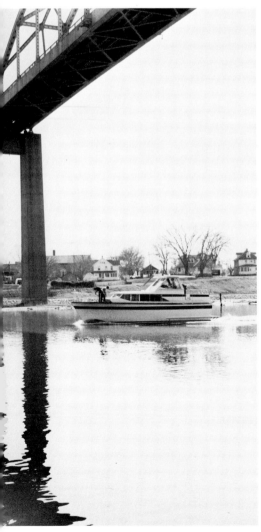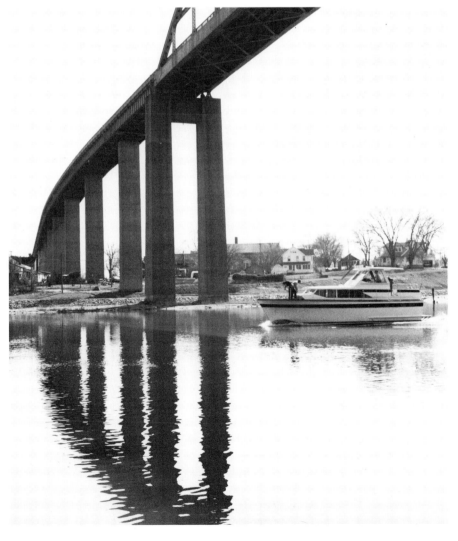

Elements of Composition

Proof Sheets

Rarely seen by amateurs, a proof sheet is the basic starting point for professionals after developing the film. Custom houses will routinely make a contact proof sheet and return it to the photographer. The proof sheet can then be used to select and indicate cropping of those prints which seem worthy.

The proof sheet on the opposite page is a typical example, composed as it is of satisfactory photos and ones that are not so good. It will prove rewarding to study, since it shows in several cases how a very minor shift in shooting angle can change a photograph rather completely. Consider the upper left photo of *Agamemnon*. It was taken from nearly dead astern and is not as effective as the one below, shot slightly off the quarter. Consider, too, the four in the center column. Note that Pioneer's bowsprit and jib boom get ridiculously large if shot from too close aboard.

And, note finally the three upper photos in the right column. The two lower ones of the three were shot from deck level and are merely acceptable. The top shot was shot from only a few feet higher, yet it is a far better photo and it was the only frame ever used from this roll. It is shown to the left, properly cropped and enlarged.

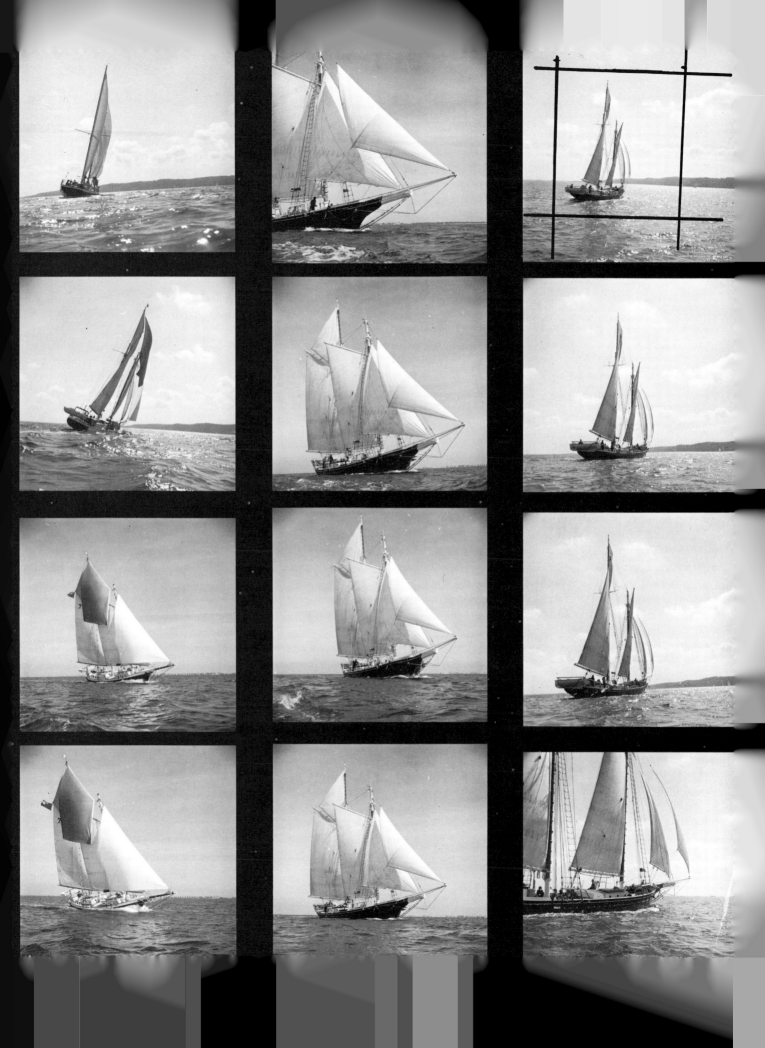

Aesthetics of Boats

Upon due reflection, it appears that the subject we are about to attempt to deal with may well be the single most important subject in this whole book. So far, we have been talking about aspects of photography common to many areas of photographic endeavor. While it is true that, as a whole, what has been discussed is more appropriate to marine photography than any other area, still everything that has been said will apply elsewhere as well. Therefore, it is likely that a good photographer will have a good working knowledge of everything that has been written so far. He will not, however, have much of a knowledge or appreciation of marine aesthetics, and it is here that most of them fall short.

Let me relate an analogous situation that happened to me this past winter. I was invited to photograph a modern dance troupe. After unraveling and solving problems of lighting and so forth, I found that I was still not achieving much. The few good photos were happenstance, more lucky accidents than skillful interpretations of the dancers' art. Having no real understanding of what they were doing or trying to do, I had two and a half strikes against me in trying to capture them on film. The important point is this: Photography of an art form requires a deep and thorough understanding of the art being photographed.

This, then is the situation facing the photographer of boats, except that he is faced with the interpretation of several levels of art, not just one. Designers design boats, builders build them, and sailors sail them. The photographer's task, over and above creating graphically beautiful photographs, is to enhance the designer's art, the builder's craft, and the sailor's skill.

To treat a boat as a graphic object solely—to treat the boat as part of the furniture in the set of a bad play, so to speak—is to miss 90 per cent of the whole. This is what most often happens, yet surely there are few man-made objects as beautiful as boats, beautiful in both the static and dynamic senses. However, it must be freely admitted that writing about beauty is a little bit simple. Beauty in many ways is in the eyes of the beholder—and was there ever a boat so ugly that someone didn't love her?

Probably not, but that is not to say that there aren't aesthetic standards in boats, just as there are in every other area. To draw a comparison, there are women who are generally accepted by all as being beautiful. Each specific woman may not do anything for a specific man, but as a group they fall within an overall set of standards, or fit a general definition. So it is with boats: while a particular boat may not appeal to a particular person, it can nevertheless be objectively viewed as beautiful, handsome, staunch, rugged, utilitarian, plain, ugly, or—worst of all—vanilla pudding, or lacking in all character.

To continue with our comparison, since all of us are humans we tend to automatically know which features of a person warrant emphasis, and which ought to be subdued. A good portrait photographer can and will do wonders at enhancing a person's basic appearance. But portrait photographers, being human, have had a lifelong familiarity with people and know what is handsome or beautiful and know what is not. Aesthetic standards for people are engrained in everyone, and a person wishing to shoot portraits has to make no special effort to acquire a sense of aesthetic appreciation of people.

The would-be marine photographer, on the other hand, might very well have to make a special effort to acquire a set of aesthetic standards for boats. Certainly he cannot hope to create great marine art without such a sense. For some, this will come more easily than for others. Those who have been around the water for a long time, those who have already developed a fine sense of judgment about boats as functioning units will have a far easier time of it than those who really don't have a clue about what boat is doing what well. Then, too, those who have spent time designing, provided they are competent designers, will find less rough water in their course than others who don't know a water line from a midships section.

Beauty in photography and beauty in design are inextricably interwoven, and perhaps the best description of what aesthetics in the marine world are all about is found in the original *Elements of Yacht Design*, written by Norman L. Skene in 1927.

"Although there are no definitely formulated rules for the attainment of beauty in design, I believe the fundamental principles governing the subject may be laid down somewhat as follows:

"To begin with, the keynote of the matter is *utility*. Every feature of the design should be an expression of some useful purpose; otherwise, it is not justified. Any innovation which constitutes a distinct improvement, however strange and repellent it may seem at first, soon becomes acceptable from the standpoint of appearance. But if it is false, added merely for looks, away with it! It cannot continue to be considered good taste for it does not fulfill the condition of utility.

"The design in its entirety should be a frank, vigorous declaration of the use to which the boat is to be put. If she is a cruiser, every line should tend to give the impression of strength, seaworthiness and comfort; if a racer, the refinement of design and construction should indicate speed; if a working boat, her sturdy lineaments should proclaim her commercial employment.

"Another important principle is *symmetry*. It has extensive application in every phase of the design. Symmetry of distribution of displacement, of distribution of weights, of the form of underbody and of topsides, are important and any design which violates this principle must fail of success. Every

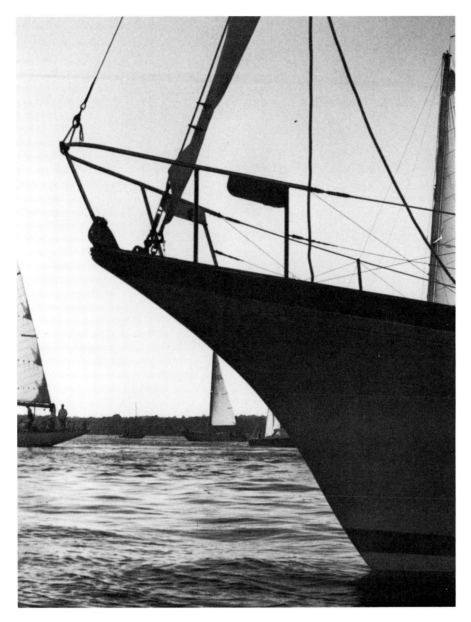

As an illustration for a page devoted to aesthetics, what else could be selected except a design by that master of marine aesthetics, Phil Rhodes? This is the stem of Thunderhead, *one of offshore racing's more handsome sights. (Rollei, yellow filter, Tri-X, 1/250 at f/16.)*

vessel is necessarily symmetrical transversely—that is, both sides are exactly alike—but longitudinal symmetry is not so necessary. Still, the forebody in its general bulk or mass should not be far different from the afterbody below and above the water. The freeboard forward will naturally be greater than at the stern, but enormously high bows and low sterns are distinctly bad for a variety of reasons. If the character of the design is such as to call for a wide, flat stern, the freeboard should not be as great as with a fine, sharp stern. It has the same bulk or volume on a smaller freeboard. Deckhouses and erections may be treated to carry out this idea of symmetry. An instance in point is the

location of the funnel in steam yachts. This should be at, or close to midlength to produce the best effect.

"Still another principle the importance of which I wish to emphasize is *harmony*. A vessel is a complex creation having many features which, however perfect in themselves, must blend into a harmonious whole. Certain types of hull call for certain rigs or certain styles of deckhouses; certain types of bow belong with certain types of stern, for while each may be beautiful, considered separately, they may be utterly incongruous both for aesthetic and practical reasons when used together. The chief components of the visible entity of the boat are the bow, stern,

contour of sheer, general freeboard, mass of deck erections, size and rake of spars, funnel, etc. It is impossible to lay down any test for harmony. Familiarity with this principle must come through practice and observation. A full appreciation of this subtle principle of harmony is evidenced only in the work of the most proficient designers. A man who has mastered it might be termed a naval artist."

A "naval artist" is what every marine photographer must be. Mr. Skene has ably laid the groundwork. On the following pages we will look at the question of aesthetics in its two natural divisions: static and dynamic aesthetics.

Static Aesthetics

By static aesthetics I mean simply the beauty (or lack thereof) of a boat all by herself, not going anywhere, not doing anything in particular.

The best way a person can acquire a sense of rightness about how a boat ought to look is to study as many boats as possible, both in the flesh, so to speak, and in photographs and in the numerous designs printed in every boating magazine. Additionally, it wouldn't hurt a bit to look through some of the available texts on marine design, not with an idea of learning how to design a boat but with the object of acquiring some knowledge of what makes boats tick.

For example, a study of design will reveal that, as in many other forms of art, arcs of circles tend to be less useful and duller than curves with a changing radius. Especially, a boat with a bottom as round as half a grapefruit will be ugly and roll like half a grapefruit would. Then, too, a sheer line that is one even, unchanging swoop from bow to stern would look ghastly. Proper sheer lines change their curve as they move from bow to stern in concert with the shape of the topsides, the plan curve of the deck, and even the profiles of the forward and after overhangs. These are but two details from a tremendously complex web of interwoven design facets.

Quite obviously, few designers manage to integrate all of the factors into a single design with total aesthetic success. Indeed, the parameters the designer is perhaps working with elimi-nates the possibility of creating beautiful boats. Maybe the best he can do with what he has to work with is to create a boat that isn't too overtly ugly. A typical example these days is the unending efforts of designers to make chunky, high-topsided boats look sleek and graceful. The necessities of the marketplace have in recent years placed a tremendous premium on internal accommodations, a fact of life which makes boats bulkier than they would be if aesthetic appeal was the prime requisite. The devices they use to cut down the apparent bulk of a boat are legion: contrasting color bands, multiple boot-tops, high crowns in decks, strategically placed ports and windows, and so forth.

Then, too, the demands of the racing circuit have downgraded aesthetics in favor of performance. This is not to say that some IOR boats aren't handsome

Dynamic Aesthetics

Boats are quite obviously always in motion, and their motion, their dynamics, are as much a part of them as their hulls, engines, sails, or hardware. Even at anchor, a boat has a life, an ambiance which is part of her.

The dynamic aesthetics of marine photography are easy to understand for a thorough boatman for they are identical to his natural, ingrained sense of the sea. Sometimes a boat is doing well, is at home in her element, and sometimes she isn't. When she is, great marine art is possible. When she is at odds with the wind and the water, you might get a picture that will appeal to the editor of a Sunday supplement but it will never mean a thing to a real boatman.

For example, let's take the more or less typical case of a boat driving upwind against a bit of a sea. There will be times when the helmsman is pinch-ing her, times when he is driving her off, times when she is rising to a sea, when she is driving into and through a sea, and times probably when she comes down flat on top of a sea, stopping her dead in her tracks. It stands to reason that the best photograph —questions of light and so forth set aside—will be the one when the boat herself is doing her best; when the sails are trimmed ideally, when the helmsman has managed to settle her down in the groove and the boat is driving along as she was born to do.

With powerboats, too, the relationship between proper performance and dynamic aesthetics is equally true. This I learned the hard way, by having a tremendous number of powerboat photographs turned down by the builder for the simple reason that they did not show the boat at her best.

This does not necessarily mean that the boats were at less than a full high and hard plane. That indeed was a factor, as we'll discuss in the powerboat section, but there are any number of other factors, too. For example, a boat being out of trim laterally will make a boat look very odd, at least on a subliminal level.

A boatman looking at a picture of a powerboat heeled over so slightly away from the camera will know something isn't right, even if he can't put his finger on it. Similarly, a boat out of trim fore and aft, either sail or power, will look wrong, wrong, wrong.

The solution to the out-of-trim boat is obviously to bring her back into trim by moving the three-hundred-pound body off the foredeck or, if the same overweight body is sitting on one side of the flying bridge, balancing him/her out with equivalent weight on the opposite side.

The objective of this example and indeed the purpose of this whole page is to underscore the importance of the boat being photographed being "right"—right in terms of outfitting, trim, and tuning, and right in what she's doing.

In selecting photographs for this

in their own vicious-looking way, but masthead rigs with their small mains lack the aesthetic stressing that was an integral part of the 3/4 rig and is part and parcel of all multimasted boats. At the very least, masthead rigs are lower than older rigs and thus modern sloops tend more to the ugly beauty of the stubby winged jet fighter than the beautiful soaring flight of the albatross.

And finally, may the boatbuilders of the world forgive me, the advent of fiberglass and the inevitable chlorox bottle appearance it has engendered have eliminated any hope of using the textures and appeals of other older materials as devices to induce or augment character in a boat portrait. Fiberglass, aluminum, and stainless steel may be highly practical, super-efficient materials but they are also antiseptic, bland zeros without any character to speak of at all.

These then are some of the problems faced by designers and, by extension, marine photographers. The solutions to them are quite properly the objective of both. The designer's work is first. He will succeed admirably or fail abysmally, or most normally he will produce a boat that is neither exceptionally handsome nor outstandingly ugly. The photographer's task is to take up where the designer left off: to enhance what the designer and builder did well, and to mask or mitigate what they did not succeed at. To do either, the photographer must know what is wrong and what is right, which brings us back to square one: my recommendation to learn as much about design as possible. An additional reference worth exploring is *The Commonsense of Yacht Design* by L. Francis Herreshoff. L. Francis, God rest his soul, was an opinionated old curmudgeon who ex-

pressed himself, whether right or wrong, in strong and colorful language. Whether or not you agree with his opinions is secondary to the fact that what he has to say about aesthetics of design will at least make you think about it. And this is what this page was supposed to do, too.

book, I came across and rejected a perfect example. It was a photograph of a schooner, and it was graphically a very interesting photograph, full of curves and shadows of her massive sail plan. I rejected it purely and simply because the jib topsail halyard hadn't been sweated up enough and the luff of the topsail was one long row of scallops. The Sunday supplement editor would have loved it; the seaman would have wondered about the strength and devotion of the foredeck gang.

Similarly, in my normal career of editing a magazine, I continually reject photographs of boats which make the boat look bad or the skipper inept, or both: the cruiser at neither displacement nor planing speeds, nose down and pushing a veritable mountain of water down the creek; the sailboat with the jib luffing or, as above, not hoisted correctly or the countless ones with boats with fenders over the side. And I tend to turn away from those photographs in which people are looking like they are in (a) a week of not talking to

each other or (b) the middle of a fire drill. While people are not, perhaps, the main center of interest in a photograph of a boat, they certainly are there, viewers see them and unconsciously react to how they look. The people are a part of the dynamic aesthetics of the photograph and since they are they should certainly be supplementing or complementing the overall objective of the photo. People looking grim, tense, and/or excited are acceptable, even desirable when the photo delineates some aspect of man's struggle for performance or survival. Foul weather requires foul-weather gear. Conversely, a photograph of relaxation on a sunny, serene afternoon can be spoiled by one or more people looking grim, determined, or just plain terrified. If the boat has to fit the water; the people have to fit the boat.

The above remarks speak as if you have control over who's on the boat and what they are wearing or doing. If you do any commercial work, this may well be true, but normally you take what you

get and work with it, and here is where patience and perhaps a little diplomacy come in. The diplomacy is useful in getting rid of the dangling fender, while patience is useful in waiting for the sea and wind and sun and skipper to all work together for however brief a period. Even a rather inept skipper steering an erratic course will have the boat right for a moment now and again, even if it is only in passing from an almost head to wind to a broad reach and back again. The problem is to wait, shutter cocked, until it all happens together.

Powerboat Photography

I wish I had a nickel for every bad powerboat photograph I've taken. I'd retire right now. No one is going to give the nickel per bad photo, but this mountain of bad powerboat photos has its virtues: I now know something about taking them right; and perhaps I can pass on to you some of the knowledge that taking a lot of bad pictures engenders.

As outlined on the previous two pages; the basic problem divides into two subproblems: static and dynamic aesthetics. In the case of most powerboats, the former—static aesthetics, or in other terms, the inherent beauty of the boat herself, represents a real problem. There simply aren't that many powerboats that can be classed as works of art. This is not to fault the boats or their designers. They are designed to perform a certain range of functions, which they do with more or less success, but it is this set of design parameters that produces boats which, in a large part, are basically boxes. At least most of them display, to a marked degree, the distressing ability to look like a box if you so much as blink your light meter at them.

This is not true of all powerboats, mind you. Many high-speed, offshore racing boats and their day-cruising derivatives, are anything but boxes. Some look as if they were going a hundred

Dawn and dusk often make the best, at least the most dramatic, photographs. This was dawn on Biscayne Bay, and although I felt a little silly asking everyone to get up that early, the results justify it, as they often do. In fact, the majority of powerboat advertisements you see these days are taken at these two times. (Rollei, Ektachrome, 1/60 at f/5.6. Note: Extreme bracketing is essential in the changing and iffy light at dawn and dusk.)

A Guide to Marine Photography

miles an hour when they are tied to the dock. Many displacement boats, too, have a definite aesthetic appeal, the appeal of the rugged purposeful workboat. Finally, some of the newer fiberglass cruisers display artistic feeling in the sculpture of their fiberglass moldings. But, the basic truism remains: the inherent beauty of most powerboats is limited.

However, if their static appeal is limited, their dynamic values are far greater and it is into this area that we must look for successful powerboat photographs. This can be done in two ways: by enhancing the motion of the boat in, on, and through the water and by shooting the boat in a locale likely to evoke an emotion with which the boat can be identified. Thus, a cruising houseboat wending her way down a lonely river, outdrives happily burbling. under the counter, speaks volumes about the joy and serenity of river cruising aboard a houseboat. A photograph of the same boat taken from the same angle with the same light but on an empty sheet of water wouldn't have anywhere near the same impact. The truth of what I am saying is underscored by the tremendous amount of time, money, and effort that production powerboat builders expend in searching out new, interesting, and exciting locales to use as frameworks for their boats.

The locale is only half of this particular story. The object of the locale is to enhance some quality or purpose of the boat; this must be complemented by the people on the boat and what they are doing. The whole package—people, activity, locale—will in some way delineate the boat's purpose and the interaction of all the elements will en-

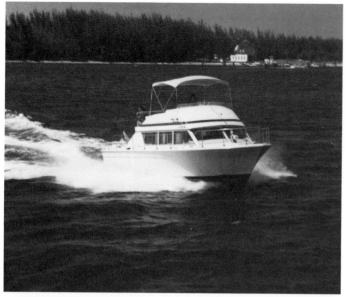

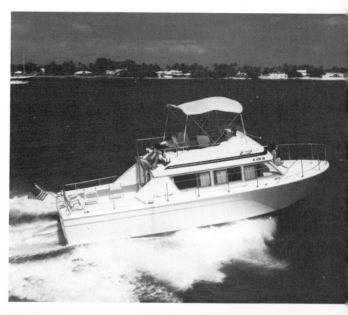

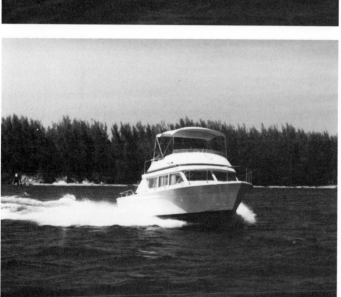

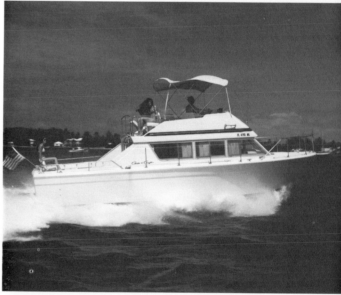

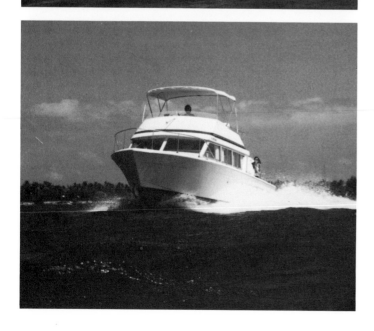

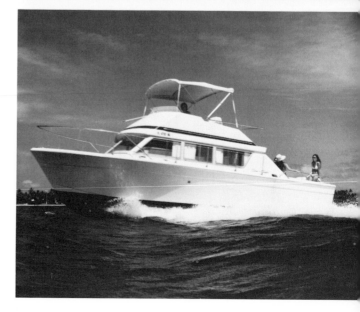

A Guide to Marine Photography

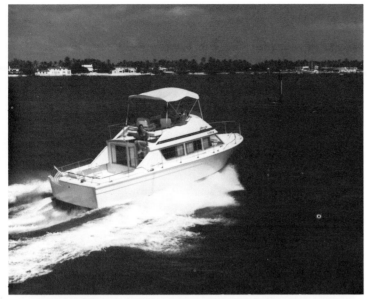

High Angle

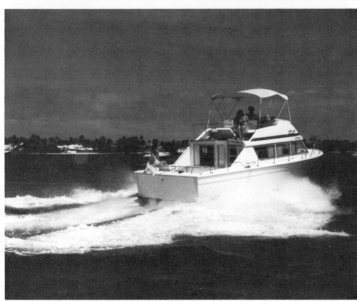

Medium Angle

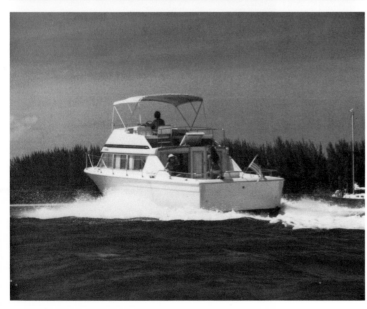

Low Angle

hance the character of the boat.

This sounds as if we are talking solely of commercial photography for advertising and promotional use, and I suppose this is true to a degree. But the same principles apply to any kind of photography of powerboats: while sailboats can be and often are treated as ends in and of themselves, powerboats usually must be cast in a framework of some sort to be most successful. This is natural, since powerboats are most useful as means to an end; be that end water-skiing, cruising, sportfishing, or scuba diving, not as ends in themselves.

This is not to say that powerboats have no aesthetic values at all, or that what values there are can't be enhanced by proper photography. They can be. In fact, smashing photographs of almost any boat can be obtained merely by following my one basic maxim of shooting either from a point higher than the boat being shot, or from water level.

The set of photographs on these pages, photographs of a Chris 33-foot Coho from three different levels and from three different angles, illustrates how bad or good a boat can look from various vantage points. A close study of this set of pictures is most important and will reveal the truth of the stated maxim. You will note that all three of the photographs taken from a high angle are acceptable. The boat looks fine coming, broadside, and going. None of the normal eye-level photographs are worth the paper they are printed on. The boat looks like a box, the horizon cuts the boat at an unfortunate level, and the whole thing is a bit of a mess. The low-angle photos are a mixture. The broadside one is bad, the transom shot is worse. Only the approaching, bow-on shot is worthy, which isn't surprising since it is probably—all else failing—the safest angle to shoot a powerboat from. Almost every powerboat looks good from a low angle, just off the bow. If you have but one frame left, and no more film, shoot her from there. You can hardly miss.

The only time this is likely to really fail badly is when the boat is white and

the sky is either overcast or there is so
much haze everything tends to lose def-
inition. When these conditions prevail
any low-angle photo will not have
enough varying values to be interest-
ing. The boat will be off-gray, the
water will be off-gray, and the sky will
be, just for variety's sake, off-gray.

If you have to shoot a photograph
under these circumstances, find some-
place high to shoot from, anything
high, a flying bridge, a tuna tower, a
high bulkhead, a bridge, or a sailboat
with spreaders you can shinny up and
sit on. The high angle may or may not
do much for the boat's looks (although
it will probably be satisfactory) but it
will surround the boat with dark-

*A sportfisherman sits for her
portrait. Heavy side lighting and
a polarizing filter—always at its
very best with the sun ninety de-
grees to the camera—conspire to
supply as much richness to this
photo as one could desire, cancel-
ling out Ektachrome film's
natural tendency to emphasize the
blue and wash out the hot colors.
(Rollei, 1/250 at f/8.)*

colored water. If the water is dark
enough, even an off-gray boat will pop
out.

This presumes you have something
high to shoot from, and as with all pow-
erboat photography that something
ought to be able to keep up with the boat
being shot. Photos of fast boats can be
and routinely are taken from fixed or
slow-moving photo platforms (the nine
sample photos here were shot from the
Bermuda 40 that is the subject of the
sample sailboat photos) but it is easier if
you have a fast boat. The photos of the
Hatteras that open this section could
not have been done except for a boat
alongside, matching her foot for foot.
That picture was taken at 1/60 of a
second, a shutter speed that would have
resulted in a pure blur if it had been
attempted from a stationary platform. If
you have to shoot a powerboat from a
fixed spot, don't attempt anything less
than 1/250 of a second while 1/500 or
even 1/1000 is safer. Panning around
with the boat helps too.

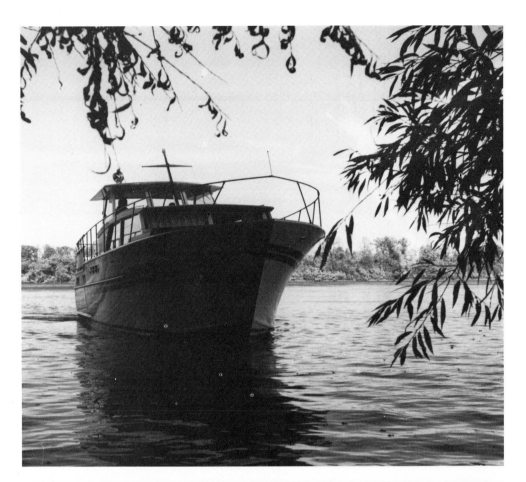

Powerboats often benefit by being photographed with another element interposed in the photo. Left, Miami's high-rise condominiums contrast nicely with the Cary and provide overtones of the ambiance in which a boat like this might be found. Above right, foliage framing the foreground sets off the sleek and shining topsides of the Shepherd cruiser. Below right, shooting through the photo boat's wake adds the feel of rough water to this Grand Banks photo shot on a flat, calm day. (Left, Rollei SL66, yellow filter, Tri-X, 1/500 at f/16. Above right, Yashica, Tri-X, 1/200 at f/16. Below right, Rollei, orange filter, Plus-X, 1/250 at f/11.)

Powerboat Photography

One of the keys to boat photography, particularly powerboat photography, is to try and cast the boat in a framework (water conditions, activity, etc.) that will complement the boat's essential character. Thus, the cruiser below was shot as she planed smoothly over the glass-calm surface of Maryland's Bohemian River; ideal conditions for a boat of this kind as anyone familiar with the type will recognize. (Yashica, Tri-X, 1/500 at f/16.)

Conversely, the deep-vee sport boat (right) required an active scene, full of speed and spray. With a basically calm sea, the only way to accomplish this was by jumping over the photo boat's wake. (Pentax, yellow filter, Tri-X, 1/500 at f/16.)

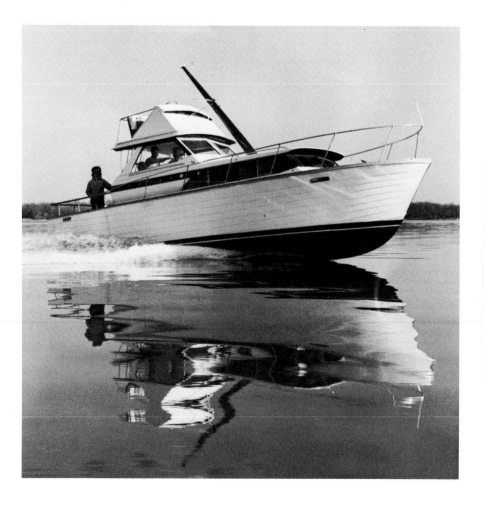

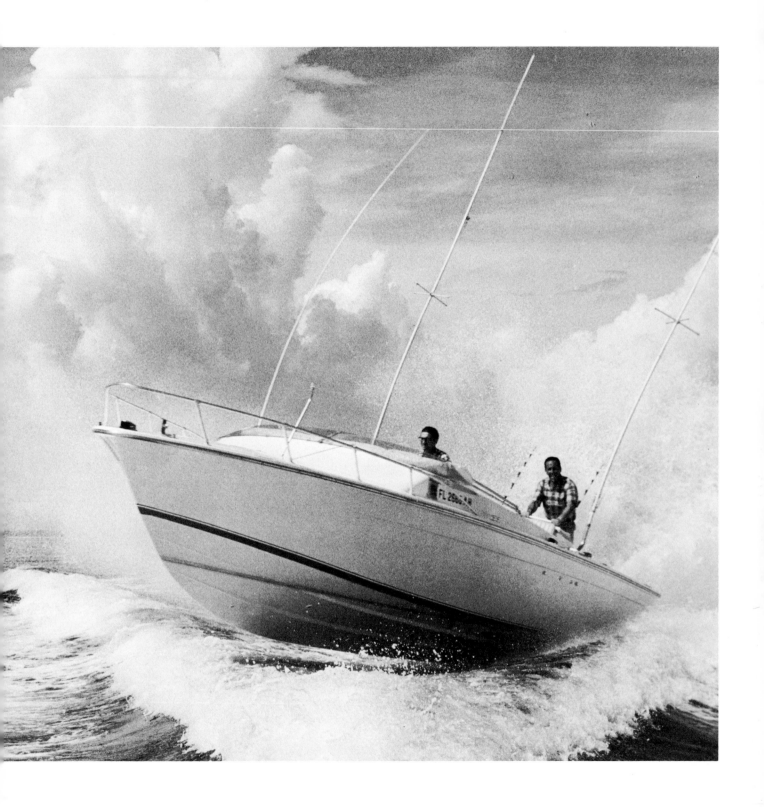

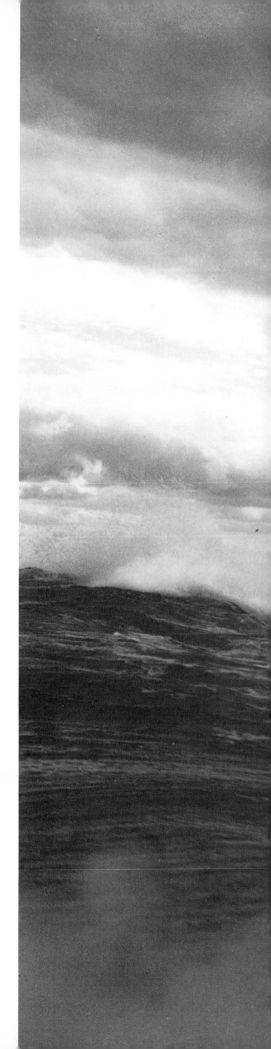

Although this is undoubtedly not the best photograph ever taken of a powerboat, I nevertheless take pride in it since it was one of those days when shooting anything is difficult, and shooting decent photographs of white powerboats nearly impossible. It was a gray, characterless day with little definition to anything. Salvation came in the form of shooting from water level, using an orange filter to bring up the clouds, using them to set off the boat, and then overprinting on high-contrast paper. (Rollei, Plus-X, 1/250 at f/8.)

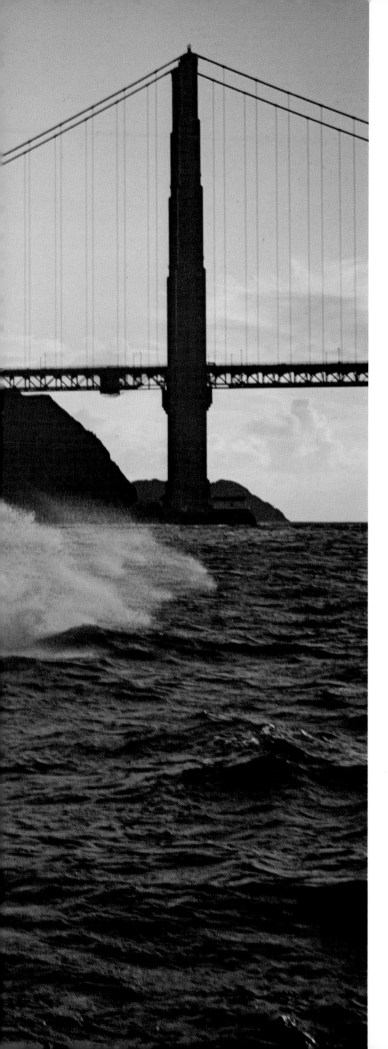

And this photograph of a Laguna dusting off a sea on her way toward the Golden Gate, I consider my best powerboat photograph. For once, everything—sun angle, the water, shooting angle, the boat herself—worked together to allow me to capture almost the entire essence of powerboating in one photograph. (Rollei, Ektachrome, 1/250 at f/8.)

Photographing Sailboats

A sailboat, being one of the most inherently lovely of man-made creatures, ought to be one of the easiest things in the world to shoot great photographs of. In many ways this is true. But there are pitfalls to waylay the unwary.

For example, many photographers, seeing the expanse of sail, the high mast, and what all, automatically reach into their bag of tricks for a wide-angle lens. The result? Usually a fat boat with a cut-off rig. I have yet to see a photo that does justice to a sailboat taken with a wide-angle lens.

Why this is so reverts back to the previous commentary about marine aesthetics. Sailboats, of all boats, are designed and hence proportioned to sail. When these proportions are seriously altered, as they are with almost anything but a normal lens, the boat looks and is wrong to the sailor's eye. Specifically the height of the masts is pragmatically decided by the designer on the basis of how much stability the boat will have. Obviously he will make the mast as high as he thinks he can without running into staying problems or taxing the stability of the boat. The result is a rig that is "right" for the boat. It is right and it looks right. If it is artificially foreshortened it will look wrong. It will look like a handkerchief perched on a canal barge.

Most sailboat photography is very simple and straightforward. Most of the time the boat is beautiful enough and all the photographer needs to do is record the way she looks accurately. Gimmicks, devices, and tricky effects can only detract from the photograph.

But that is not to say that every boat is beautiful from every angle and under every circumstance. Surely there is no activity more affected by the weather gods than shooting sailboats. Sun *and* wind must both collaborate with the photographer to achieve superior results.

To support this I've studied all of the more common books of sailboat photos and concluded that the vast bulk of them were shot on the kind of days that are very, very uncommon in most parts of the country. The ideal combination of strongish wind and bright sun is not often arranged. In the northeast, for example, the combination only occurs after the passage of a cold front when the wind is northwest and if you stand on your toes you can see forever.

And, to compound the problem, a lot of wind is necessary for the vitality and strength you are accustomed to seeing in those sailing photos normally called great. Normal, pleasant eight to ten knots sailing breezes will produce nice pictures but they won't have the oomph necessary for magnificence.

A crystalline day, a decent breeze, and a beautiful schooner like Puritan: *three elements that make any photographer look good. (Rollei, orange filter, Plus-X, 1/250 at f/11.)*

Although this fact presents no insurmountable problems (beyond seeing that the boat you're shooting from is a good, sturdy boat), it can present problems in detail since, as the photographs on the following pages indicate, most sailboats look better from their lee side. Shooting the leeward side of a boat means that you have to shoot *toward* the wind. If you are keeping pace with a boat banging along at six or seven knots, this will probably mean a lot of spray, especially if you are shooting at a low angle. Three solutions to keeping

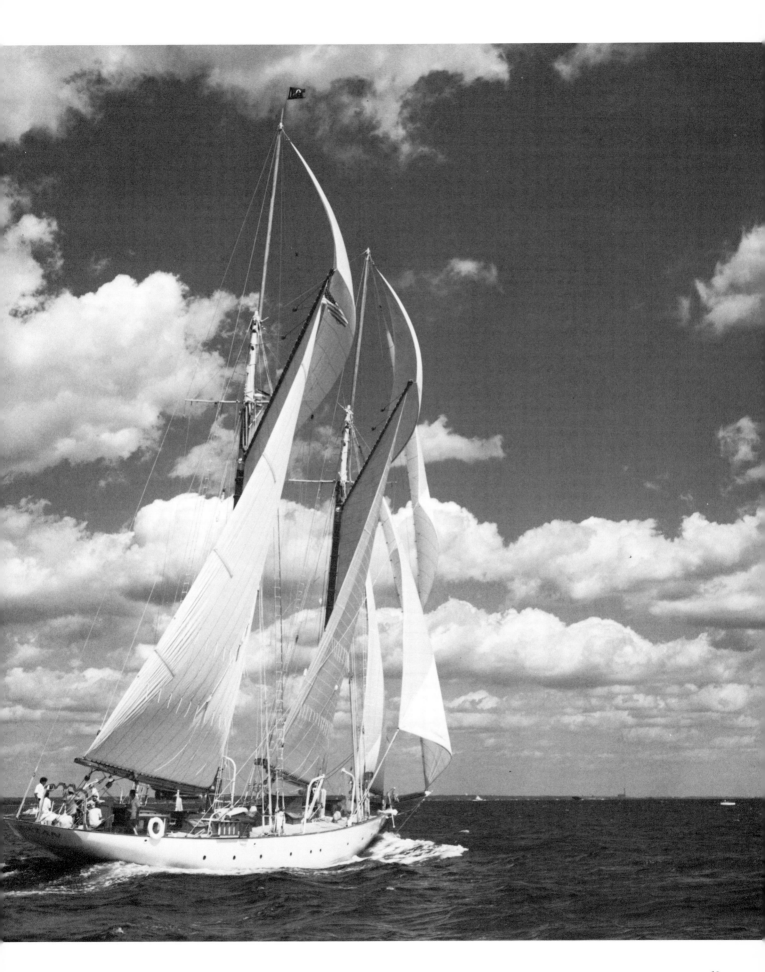

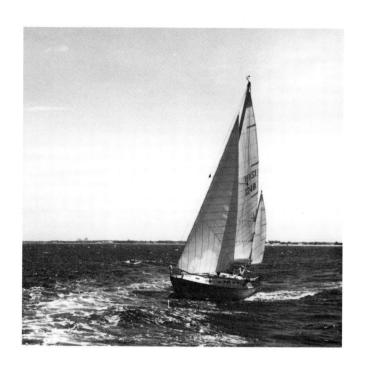

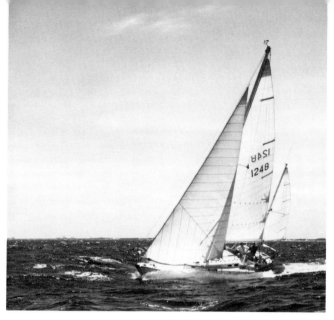

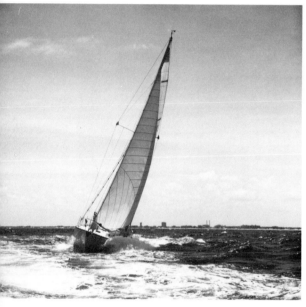

Marelle, *a Bermuda 40, held her course while the photo boat made a full circle around her. The purpose was to illustrate how one boat appears from every angle. As you can tell, a boat as stocky as a Bermuda 40 is not uniformly handsome from every angle. From some angles, in fact, her appearance is anything but sylphlike and graceful. As is most common among sailboats, she looks better from the lee side, and, again in common with most sailboats, looks best from the lee quarter.*

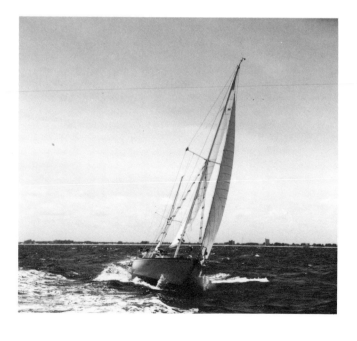

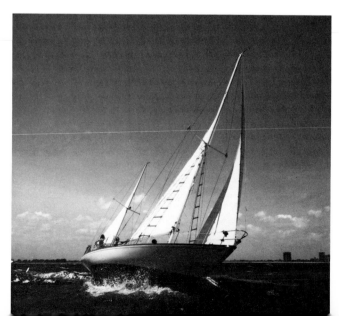

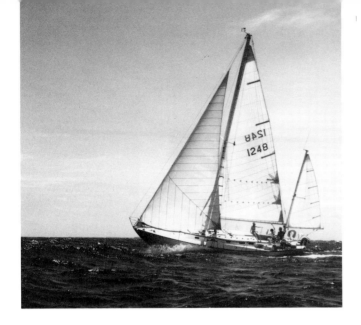

This group of photos was shot from about ten feet off the water, a distance that varied considerably as first one boat and then the other rose to or sank into a sea. As with a great number of marine photographs, there was a lot more sea running than is apparent in the photos. These seas could have been emphasized from shooting near water level, but quite frankly, it was too rough to shoot from anything but the flying bridge of the photo boat. (All photos, Rollei, orange filter, Plus-X, 1/500 at f/8.)

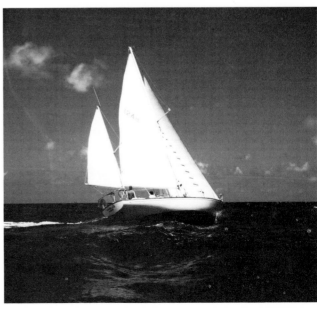

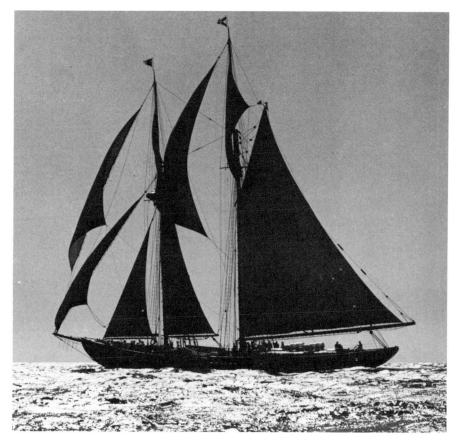

the camera dry are: keep it in a plastic bag, use a waterproof camera, and—the one I most often use—move well ahead of the sailboat, stop the powerboat, and shoot as the sailboat thunders by to windward.

All that, of course, speaks to the problem of shooting when the wind is blowing hard. When the wind isn't, the problem of keeping the camera dry isn't present, but a host of others takes its place.

When it is truly calm, glassy calm, other kinds of worthwhile photos present themselves. Reflections on an oily sea of a boat slowly rolling her way to nowhere can often make a very powerful photograph, if only of the frustrations and boredom of being becalmed.

The biggest problem area lies between no wind and enough wind. When what wind there is falls into the crack between none and enough, a straight, simple boat portrait is likely to be disappointing. My own way of handling these in-between situations is to introduce another element. This can be by trying to photograph the boat in such a way as to suggest the fun, the serenity the crew on board is having merely sailing along. Another is to back-light the boat so that the boat is now sailing across a sun-flecked sea.

However, good wind or none, some sailboats these days are problems. The current craze of jamming full headroom and berths for the second division into a tiny boat has resulted in numberless aesthetic horrors on the water. These high-topsided, tubby boxes present some interesting challenges to the photographer since he must, in effect, try to make a shoe box look graceful. It ain't easy, but if you're willing to make the attempt, you can at least make the boat presentable if not beautiful. Hard and fast guidelines would be a mistake, as the boats differ too widely. However, two directions to try are very low angles, where you might be able to interpose a wave between you and the boat, thus cutting down the apparent topside height, and very high angles, which will automatically reduce the apparent height and bulk of the boat.

Ah, for the good old days when designers were artists and sailors first, and motel designers last.

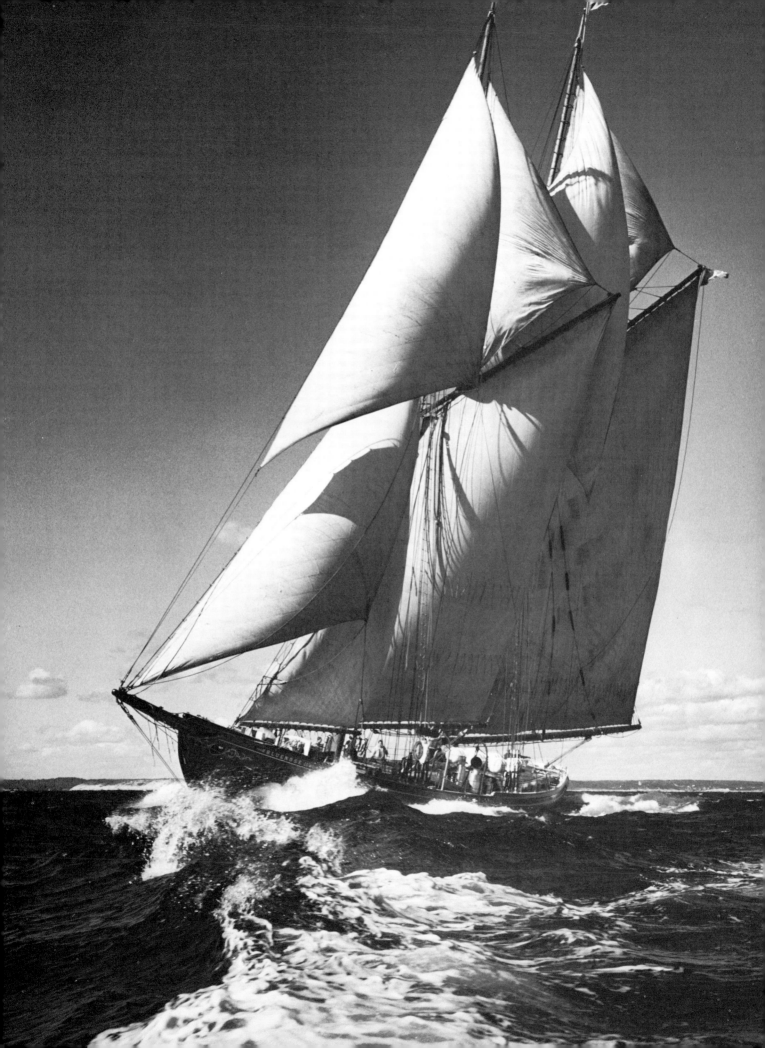

PROBLEMS AND SOLUTIONS, I AND II

I. Right: *All small sailboats are difficult to shoot without giving them overtones of bathtub toys. The solution used for the Windsurfer was to get in the water with a Nikonos loaded with Kodachrome and bang away at 1/250 at f/8 as she sailed by.*

II. Below: *I freely admit that the photo-graph of the Gulfstar 41 here is not a prize. Yet, considering that it was a very hazy, zero sort of day on nearly windless Tampa Bay, getting anything with Ektachrome that wasn't all shades of blue is a miracle. The solution was to underexpose and shoot from a bit of a high angle (twelve feet) to pick up what sparkle there was on the water from a fairly high sun.*

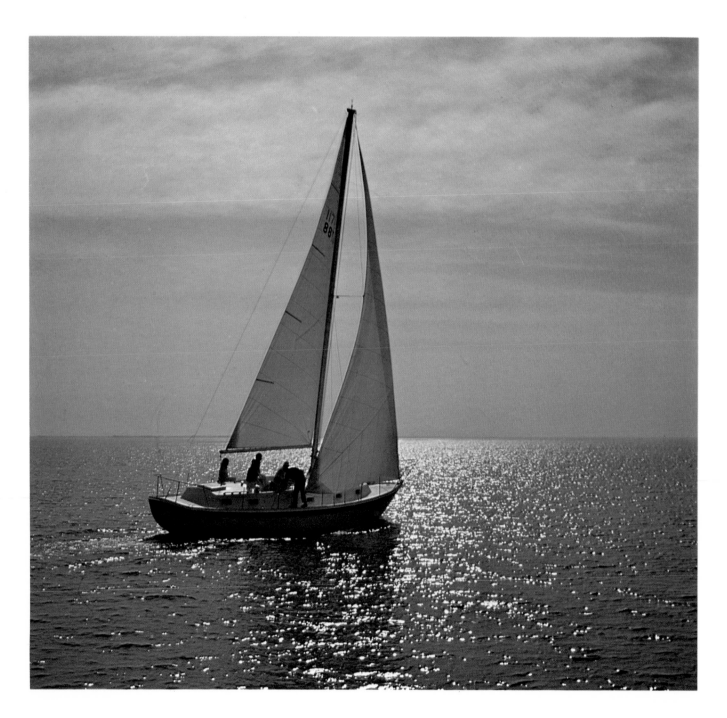

A Guide to Marine Photography

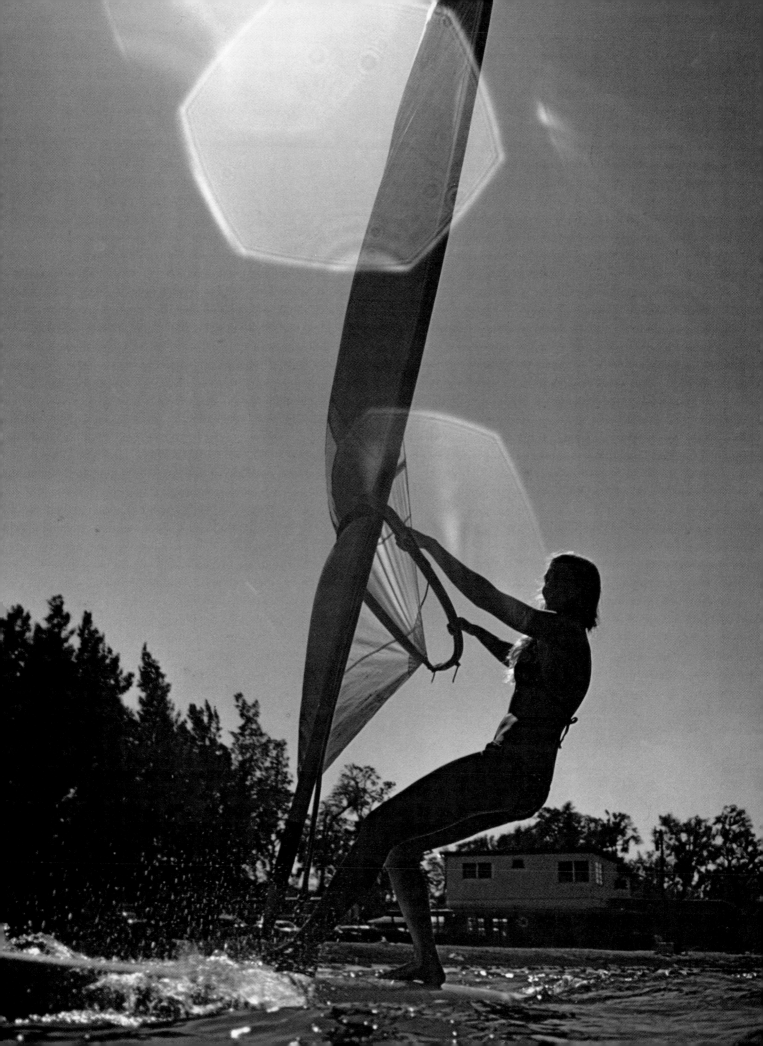

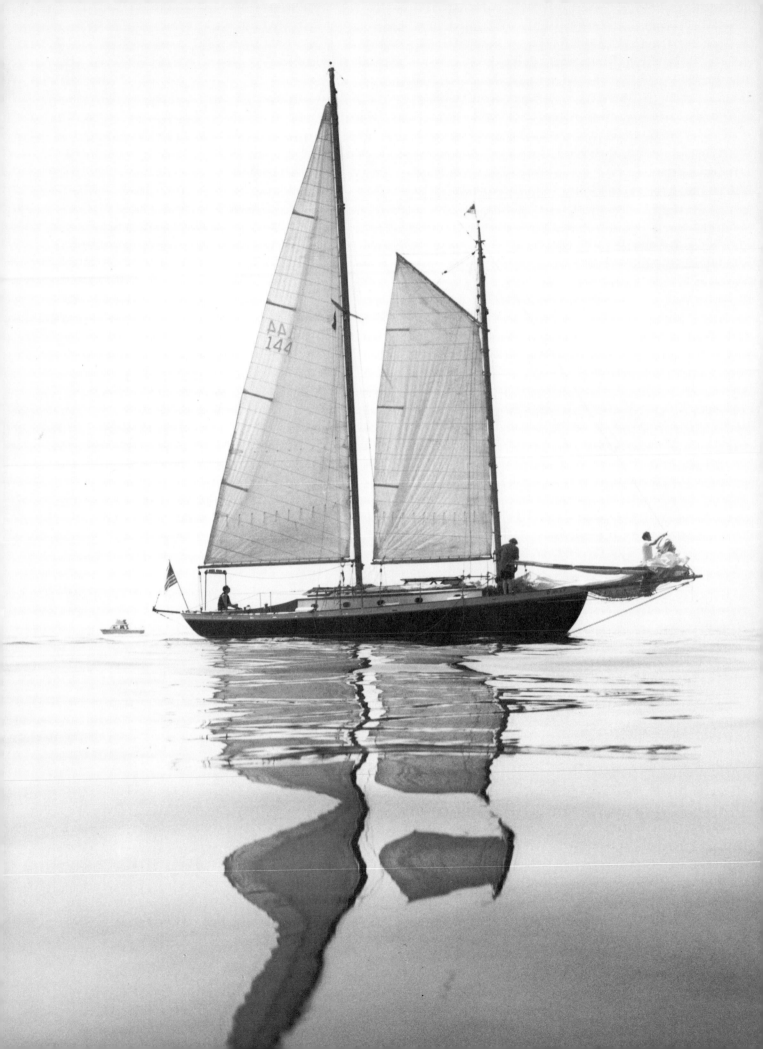

PROBLEMS AND SOLUTIONS, III

The day of no wind at all is not necessarily the problem it appears to be. To be sure, real sailing photos are impossible, but two other possibilities are suggested here. To the left is a schooner powering home, surely one of the water's more common sights. (Rollei, orange filter, Plus-X, 1/250 at f/11.) To the right is a different solution. Photographing the boredom and frustration of being becalmed by playing up the sagging sails and drooping sailors as they sweat in the broiling sun of Tampa Bay during the 1966 One-of-a-kind regatta. (Pentax, Tri-X, 1/500 at f/16.)

Photographing Sailboats

Two of sailing's many moods are reflected in this pairing. Below, a serene run up Tampa Bay as the sea breeze fades at the end of day. (Rollei, conversion from an Ektachrome transparency, 1/250 at f/11.) Right: Exhilaration—and a touch of fear—mark this headlong flight up the Niagara River by a Shark running home before a strong northerly gale. (Yashica, yellow filter, Tri-X, 1/500 at f/16.)

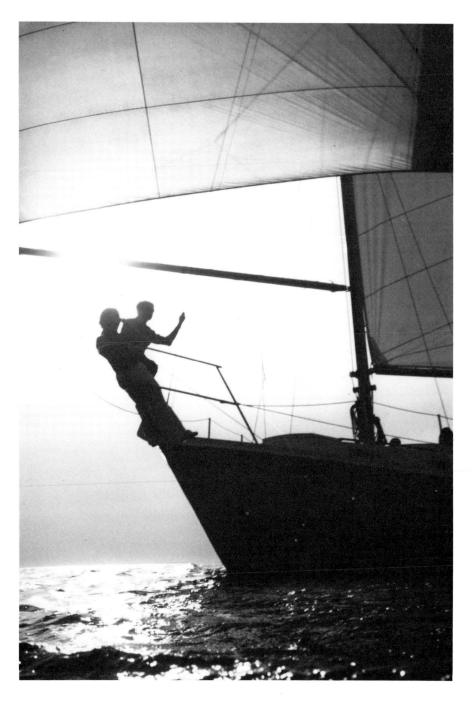

A Guide to Marine Photography

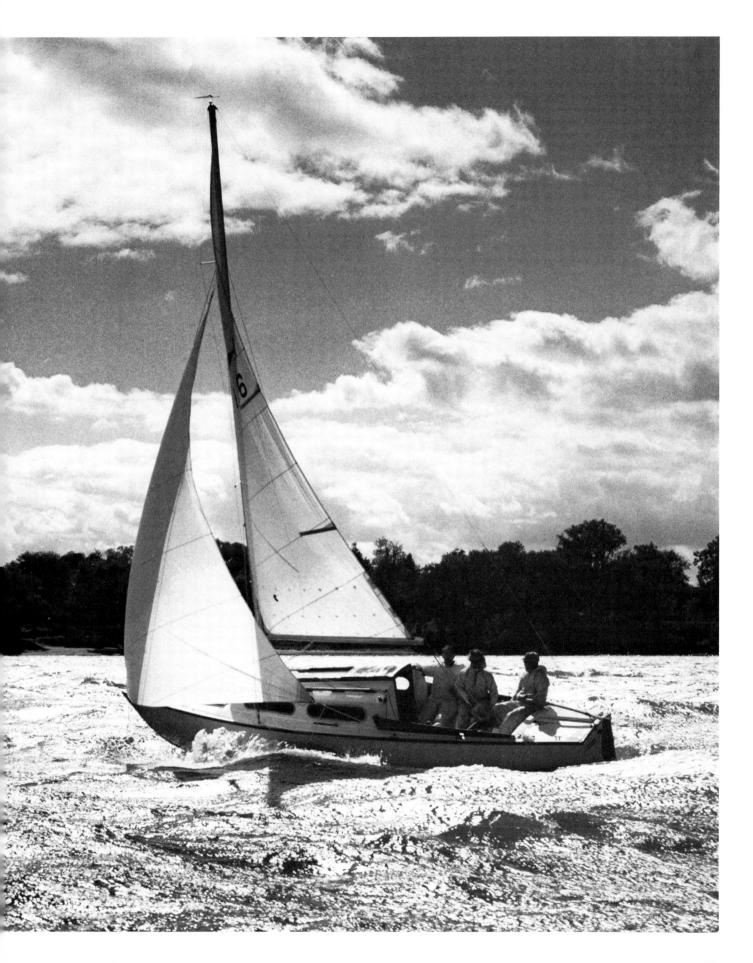

Back lighting and side lighting set two more sailing moods. Left, running toward home well in the lead is a distinct pleasure for the racing person. However, this skipper's pleasure could have been reduced considerably by photo boat interference if (a) his lead had been less, (b) the day was less rough than it was, and (c) the skipper in question wasn't a good friend. Before you move so that your wash will even touch a racing sailboat, think of the effect it might have. (Also note that some racing types are super touchy. They start screaming when you're still over the horizon.) (Rollei, orange filter, Plus-X, 1/250 at f/11.) Right, the Herreshoff ketch Circe *lifts to her first swell upon departing St. Thomas on a charter cruise. This was among the first photos I ever took and it was done with a Yashica on Verichrome film. I have to attribute my success on that first trip to just plain blind luck.*

There is quite a story behind this photograph of Bill Wellington's own 47, Rebel Venture. *I tried photographing her first in Miami in February without much success. If it wasn't overcast, it was flat calm. After several hours of struggle, we gave up. In June we tried again. This time en route to the Bahamas, in the Bahamas, and coming back from same. Again, the weather gods mocked us by keeping the winds below any useful level. Since a major magazine feature rested on taking a successful photo, I couldn't give up. I tried everything. I shot her through trees, from hills, and from a rubber boat. I even went overboard in the Gulf Stream with a Nikonos (and put the icing on the cake by scaring myself with a large gray shark). This is the best of the bunch. It was done with a Rollei from the rubber boat (which by this time had lost its outboard and was adrift toward some rather ugly coral). It was purposely underexposed to saturate the sky and the water. The whiteness of the sails was enhanced in the printing process and there was less wind blowing than is apparent. Some of it is real wind but most of it was made by the boat's Ford diesel. (Polarizing filter, Ektachrome, 1/250 at f/11.)*

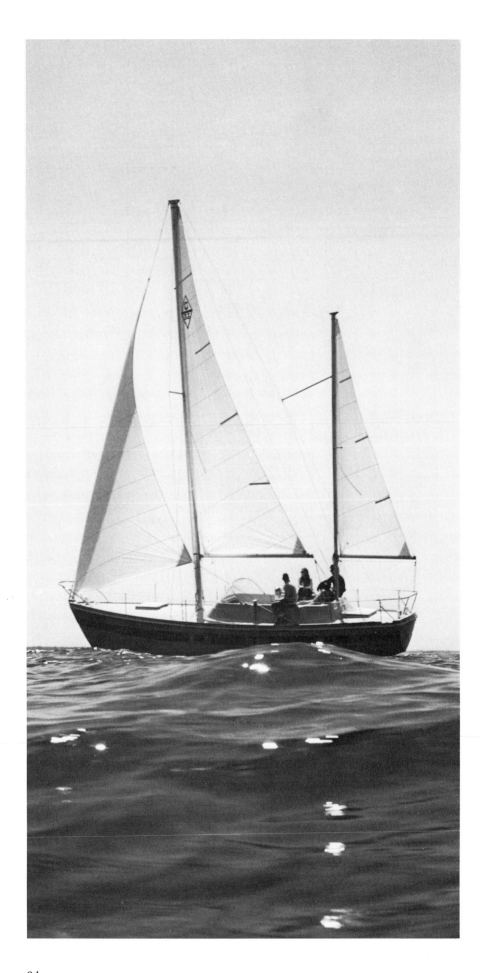

Two ways of making high top-sided boats look less high. One (right) is to wait until it's blowing like stink and shoot from the lee side. This is the Pearson 390 and most of her bulk has effectively been hidden.

A second way, when the wind won't cooperate, is to try and hide part of the topsides behind a wave. This requires shooting from just above the water (six inches or less in this case) and waiting until a healthy wave comes along. (Rollei, yellow filter, Tri-X, 1/500 at f/16.)

A Guide to Marine Photography

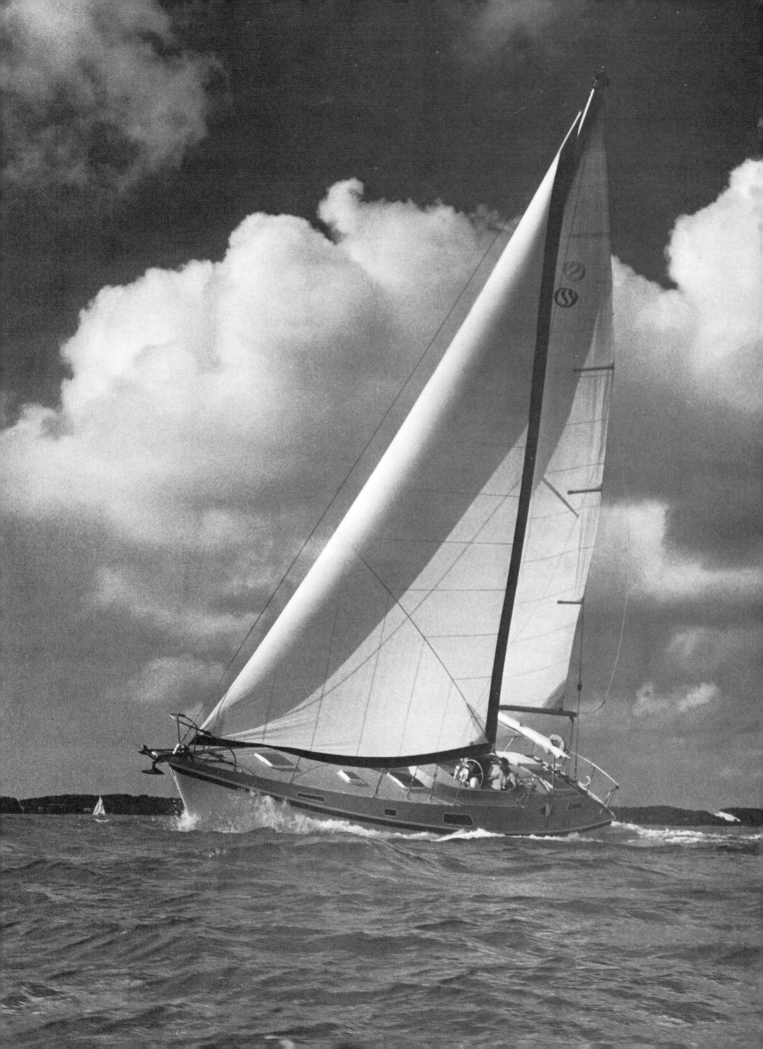

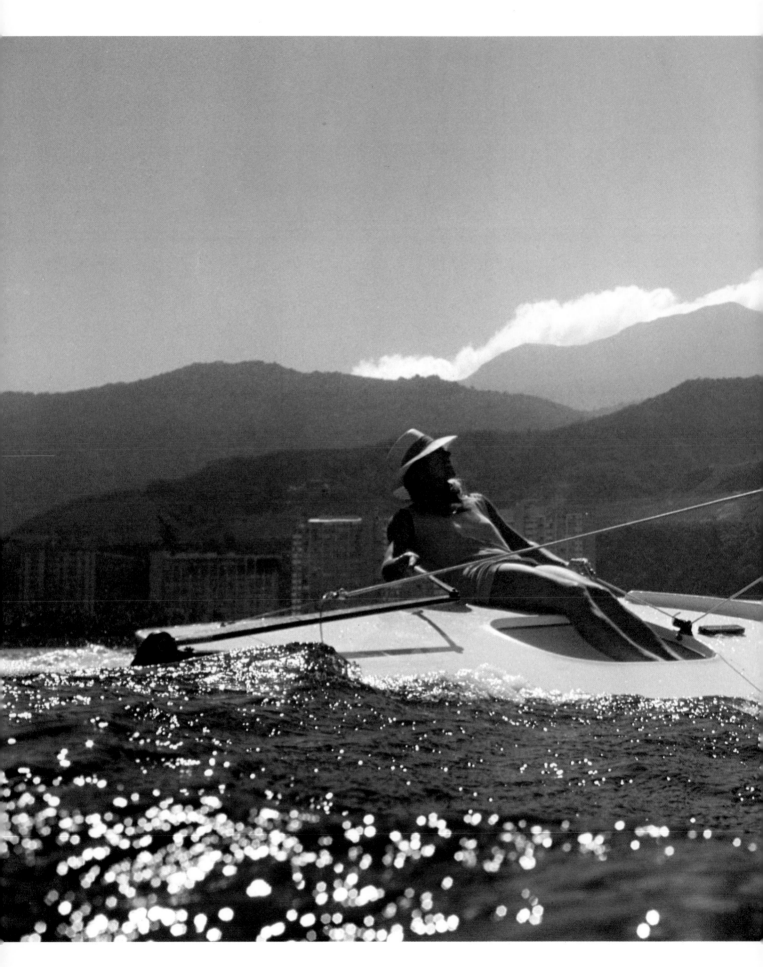

A Guide to Marine Photography

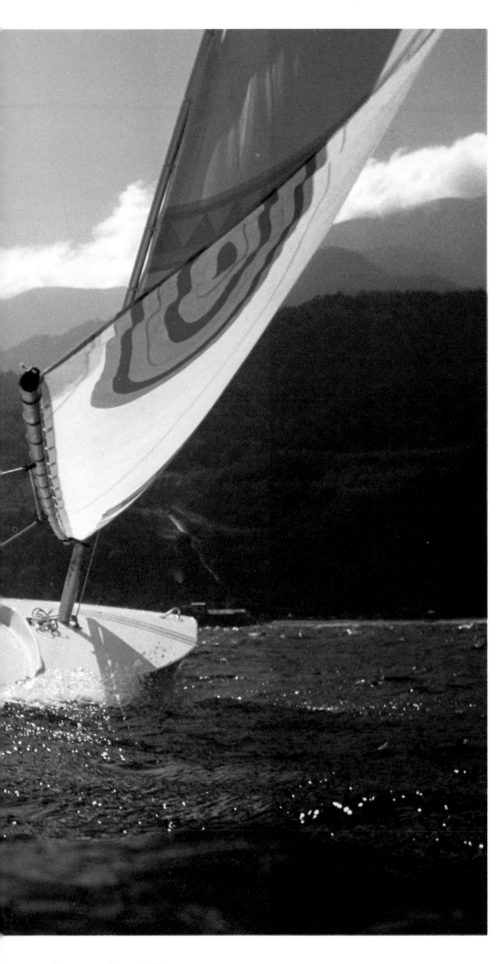

Most days, shooting on the water is punctuated by things going wrong. Some days everything goes wrong. Other days only a few things fail. However, once in a great while everything goes right and the afternoon I shot this Sunfish off the coast of Venezuela was one of those days. Of the thirty-six exposures taken, maybe a dozen were good enough to be shown here. Obviously, I like this one the best. The color of the sea, the sky, the Pucci-designed mainsail, and Heather Klein's outfit all complement each other. Although it doesn't show in this photo, there was quite a sea running, a fact I was very much aware of since I was in it with my Nikonos. (Kodachrome, 1/250 at f/8.)

Different strokes for different folks goes the saying, and what could be more diverse in the sailing world than a funky trimaran about to be zonked with a cold front in the Abacos and the twelve-meter Columbia looking her lovely self off the coast of southern California? Filters played an important role in both photos. In the case of the twelve meter, an orange filter deepened the color of the water and the spinnaker. With

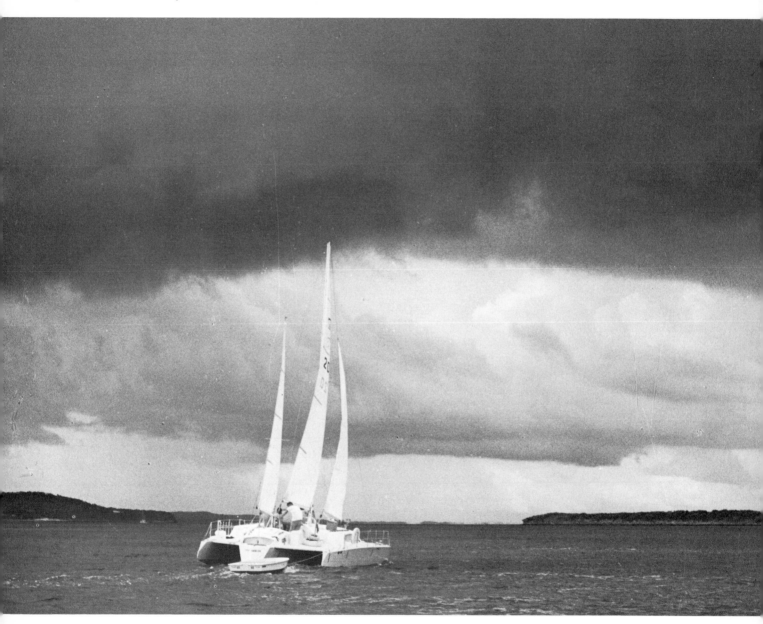

the trimaran, a red filter kept the boat white while making the clouds darker and more ominous (and they were ominous enough). Cropping, too, in the case of the trimaran photo, enhanced what the photo was trying to say: the immensity of nature compared to our puny and presumptuous boats. (Pentax, Tri-X, 1/125 at f/5.6. Right, Rollei, Plus-X, 1/250 at f/11.)

A Guide to Marine Photography

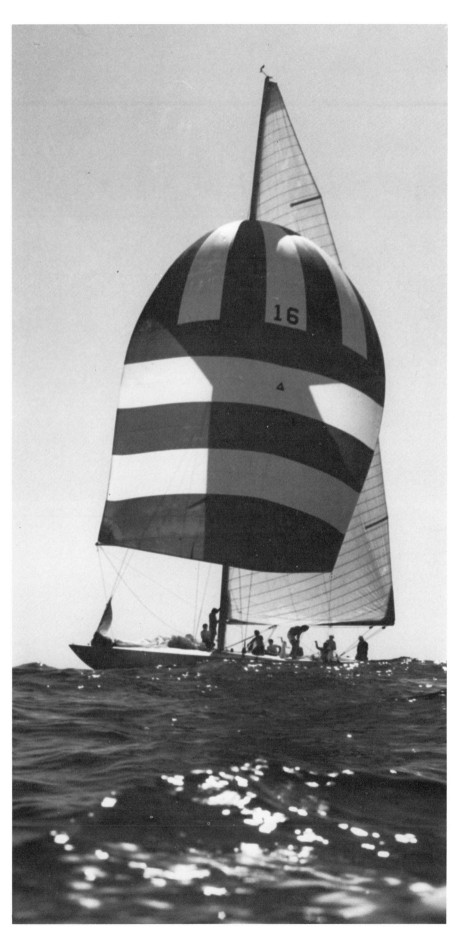

Photographing Sailboats

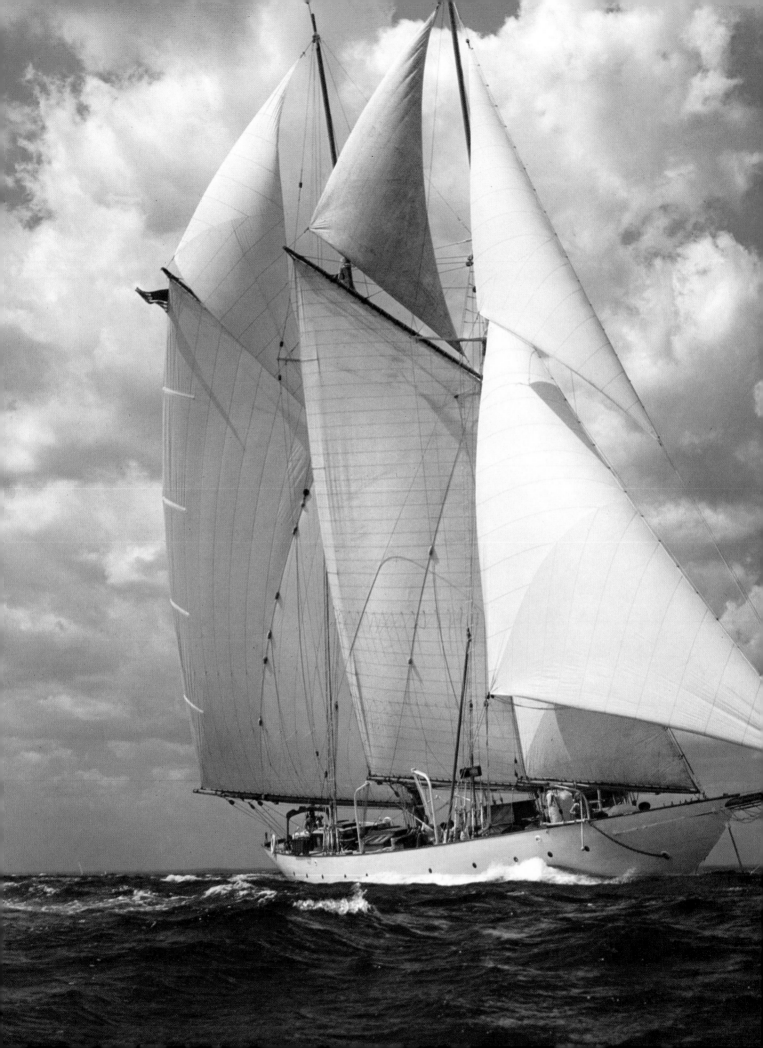

A pair of queens come down the Sound, broad reaching before a sparkling north-westerly. In the foreground is the 106-foot Puritan, *while in the background is the world famous schooner* Nina. *It is rare to find* one *boat like this to photograph. To find two at the same time makes a heady brew for any photographer. The photo was shot from about a foot above the water to enhance the relationship between the two boats and to emphasize the size of the* Puritan. *(Rollei, Ektachrome, 1/250 at f/11.)*

And, quite logically, since this is the last photograph in the sailing section, here is what I consider to be my best. The sloop is Ann, *the champion International One Design on Long Island Sound,* beating toward the weather mark in a gusty northerly on a crystal-clear, gorgeous afternoon. A great day for either sailing or shooting sailboats. *(Rollei, orange filter, Plus-X, 1/250 at f/11.)*

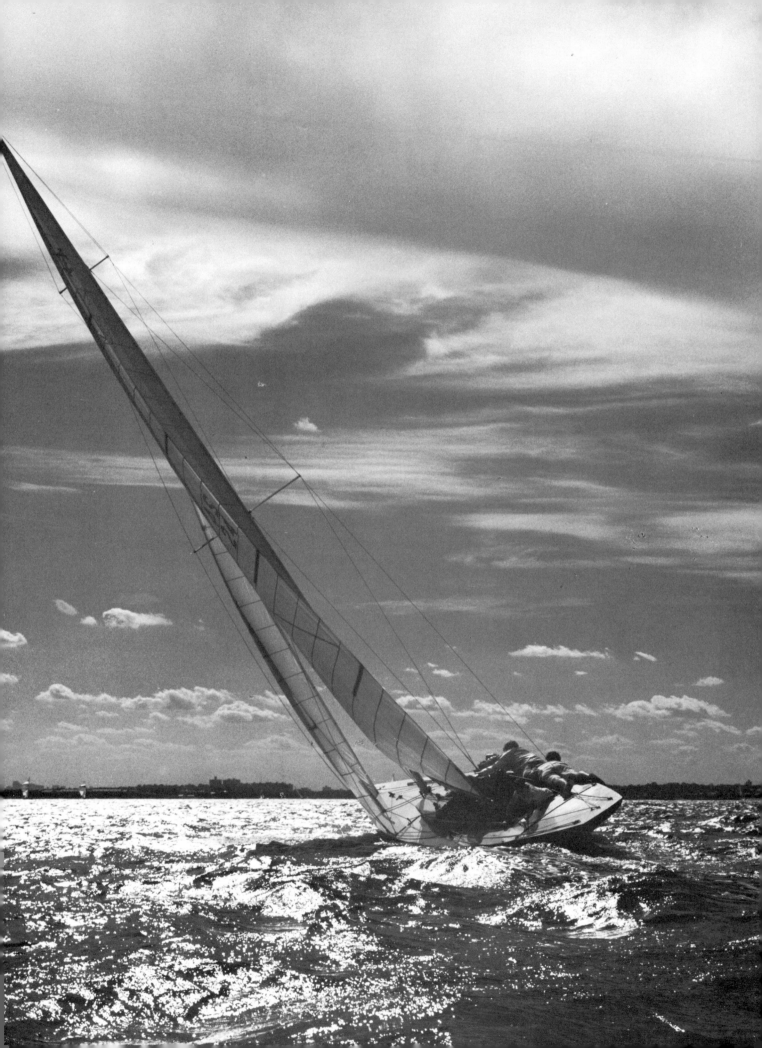

Photojournalism

So far, we've concentrated on isolated boats in the singular. One boat at a time, so to speak, and a boat only in the context of water. Here, and in the section on cruising photography that follows, we will speak more of boats together and/or boats within the context of an overall event or story.

(Admittedly, as the editor of a national boating magazine, some of the rationale behind these two sections is pure and simple self-defense. Perhaps, by outlining some of the ways to make event and cruising photos better, I won't be quite so deluged with bad photography.)

Event photography can be approached on several different levels and for a variety of reasons. The reasons are quite obvious. One is to make money, while a second valid motivation is to have fun, both in the doing and in the showing later. The levels on which an event can be photographed range from the straightforward news approach up to and including a slice of social commentary. I must confess, as the photographs on the following pages clearly show, that I am far more interested in the latter than the former.

However, the various levels aren't mutually exclusive. The news approach doesn't eliminate covering the event in more depth as well. In fact, any in-depth coverage would have to include all the photographs that a news story would (i.e., shots of the boats racing, the winner finishing, the winner getting his trophy). Without them the in-depth story would lose its focus. I clearly recall a set of regatta spectator photographs that were excellent, yet there was no way of using them, as there was no photograph of what they were watching. There was no continuity between the various photographs.

No, the event is the thing. It is the focal point of everyone who is there and it must remain, however far afield your photographs might wander, the focal point for you, as well. Let us, therefore, look first at the kind of photographs straight news coverage might entail.

Simple, straightforward race coverage can be broken down almost as concretely as the list of photographs a wedding photographer is supposed to take (throwing the bouquet, cutting the cake, etc., etc.). The basics are: the start: two or more boats tussling at some point on the course, especially a mark; the winner finishing (one hopes with the judges' or committee boat in the shot); the winner getting his trophy. This is the straight news level.

The next level of completeness still involves only the race and racers. This level would include getting ready, more detailed coverage of the race, including closeups of people engrossed in what they are doing, putting the boats away, and photos of the socializing that usually surrounds the awards ceremony. This amount of completeness could be called in-depth news coverage and be entirely adequate for all newspapers and most magazines.

However, this kind of coverage could easily move in the feature area by a number of simple and not so simple expedients. The simplest is to merely show more and more detailed coverage. An equally simple but less easy way is to key the story to one specific boat and her crew. You can go as far as you like with this, but even if the shots are few and simple, the story then becomes a very humanized one of specific people involved in a specific activity.

The grand approach, and the one that is nearest and dearest to my own heart, is to do all of these things plus become involved in the whole ambiance of the event, answering not only the question of what they are doing, but probing into why they are doing it as well. Any event, however humble, has more faces than just the obvious one of the event itself. For example, mates waiting

ashore while their spouses do their collective thing afloat are as much of a study as the boats themselves.

My preoccupation with events as overall entities betrays my editorial background (or is it the other way around?), yet I do believe that there is a great deal of personal satisfaction in this brand of photojournalism for its own sake. Going out and "doing" a race, a regatta, or a rendezvous contains more than the mere satisfaction of shooting one or more good pictures. It has that, but it also has the satisfaction of the storyteller. Several individual good photos are fun to have and to show; several photos that relate to each other and tell a story are that much better.

On the several pages that follow, I have presented the coverage of a number of widely varying events. There are two sailing events and one power sailing event and all three were selected because they represent such divergent ways people have of competing afloat and getting together ashore.

All three were covered with exactly the same equipment as outlined previously: a Rolleiflex and a Pentax. However, the Pentax bore the brunt of the work since a multiplicity of lenses is very nearly essential for this kind of work. Whereas in shooting individual boats you might normally have the option of moving the boat or yourself into a desirable location, in event coverage

you rarely have the option of moving about at will. Even a good photo boat with a good driver (a combination often sought but rarely found) is not a total answer since interference with racers will do nothing for your popularity. You must stay clear, meaning farther away from the action than you'd like. Longer lenses mean getting closeups when closeups wouldn't be possible otherwise.

This is true ashore, too, since people react differently when they know they are having their picture taken. If you're out to get photographs of people into their own thing and not posing for you, long lenses are essential.

At this point, someone who might be thinking of this sort of thing is thinking about the permissibility of publishing people's photos without releases. If you are thinking that you will have to run around and get releases from everyone you take a picture of, you can rest easy. As far as I am aware, and I've looked into it in fair depth, people attending public events waive their right of privacy by the simple act of attending. Anyone at a public happening, either planned (as a regatta) or unplanned (as a fire) is fair game.

(However, while we are on the subject, unless they are newsworthy in their own right, people merely sailing along on their boat are *not* fair game. They have as much right to their privacy on the water as they would have

sitting inside their own home, and if you publish a photograph of them—and publishing can mean the simple act of showing the photograph to someone else—without their permission, they can object, and in court, too. Normally, of course, people are more flattered than bothered by having a photo of their boat taken and this problem isn't worth thinking about overmuch. Even if they do sue, they still have to demonstrate that the publication of their picture did them harm, so under most normal circumstances releases aren't really necessary. Do, however, keep it in mind, if you come upon a shot to which the subjects might object, for example, streaking around the deck.)

Almost a hundred Sunfish are visible in this photograph of the start of one of the world's championship races in Venezuela. It is a good key photo for a story about the event, and will hold all the photos taken around the perimeter of the event together. (Rollei, yellow filter, Tri-X, 1/500 at f/16.)

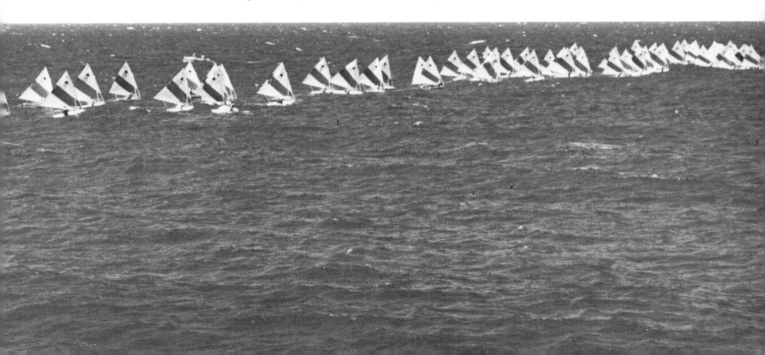

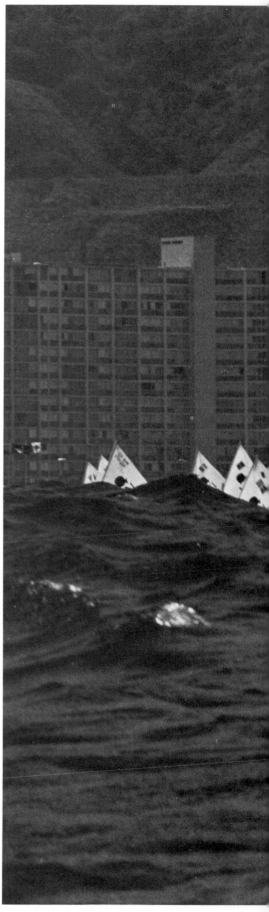

SUNFISH CHAMPIONSHIP

Success at event photography rests on picking out those details which, in the aggregate, tell the story of the event. On these pages and on the two that follow is an assortment of Sunfish Championship photos. Individually, they aren't all that much but together they tell a story about this event and about sailing events in general. On this page there is the event itself (right), one of the competitors doing something obscure with his boat (below), a young man waiting and looking cheerful (left), a young woman waiting and looking not so cheerful (above right), and one racer's answer to painful hiking out.

A Guide to Marine Photography

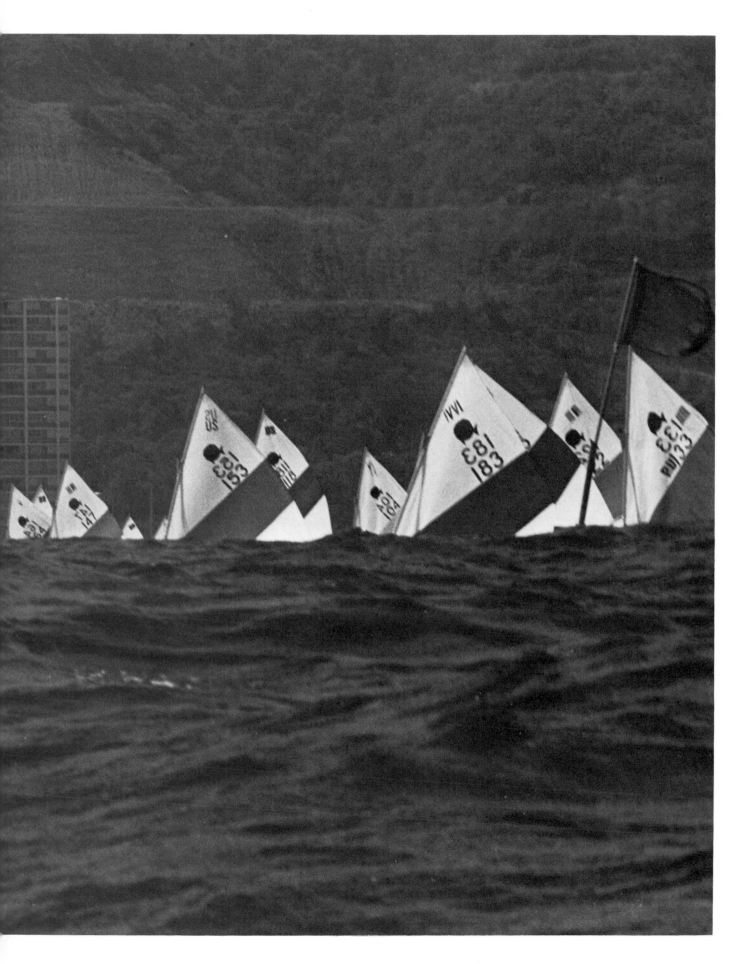

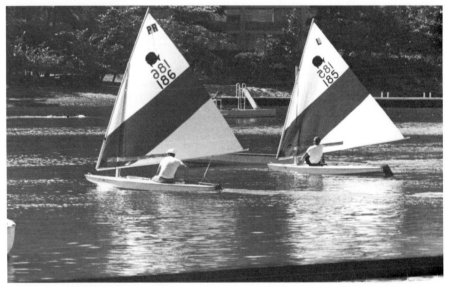

And, continuing the Sunfish coverage, we have on this page a fellow engrossed in reading the rule book (upper left), two boats slipping back to the dock (center left), a young man polishing his centerboard assisted and distracted by a friend (lower left), and one of the several thousand young, bikinied Venezuelans at the race taking her ease and totally ignoring the four boats running toward the leeward mark.

All of these photos were done with relatively long lenses (up to 200 mm) on Tri-X film in a Pentax. Long lenses are essential in this kind of photojournalism to catch expressions and moods spoiled by a nearby camera, and to replace the mobility you might enjoy in less structured settings. Long lenses will move boats, people, and objects closer when you can't move yourself.

A Guide to Marine Photography

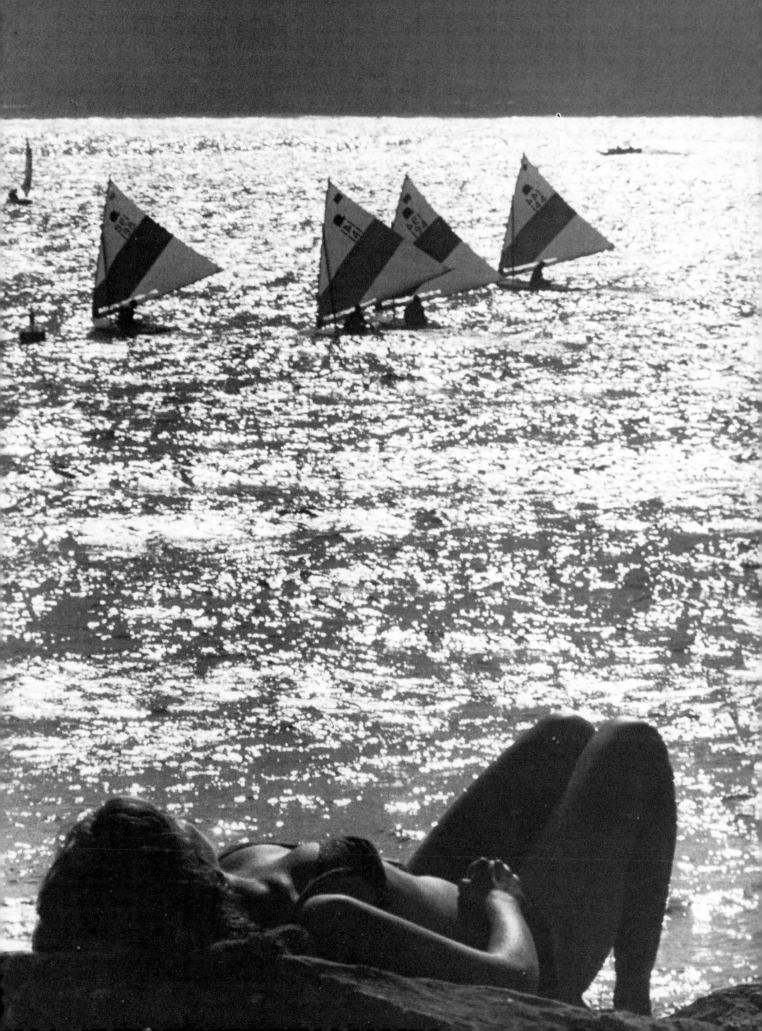

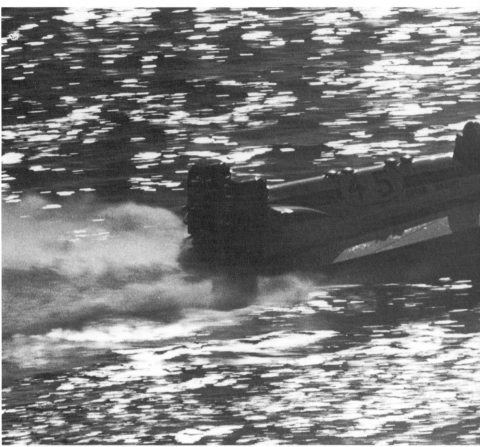

A Guide to Marine Photography

OUTBOARD CHAMPIONSHIP

From Venezuela, we travel directly to Lake Havasu, Arizona, for the World's Outboard Championships. Once again, the workhorses are the long lenses for shooting closeups of people from not so close, and pulling faraway boats into apparent nearness. However, be warned: long lenses and fast-moving boats are a tough combination. The only solution is to pan around as the boat flashes by, trying to keep the boat centered. (Centered—hah!—keeping it in the viewfinder at all is tough enough.) Be prepared to shoot many to get one. In covering a fast-moving event like this with a lot going on ashore and afloat, I wouldn't spend too much time worrying about exact exposures. It is more useful to expend your limited time on finding and composing photos and letting any exposure errors be compensated for in processing and printing. Although hardly recommended, a black-and-white photo can be three or four stops out and still produce an acceptable print.

A good photo poorly exposed is better than a turkey exposed on the money. At least for one of them there is hope. (All Tri-X with no filter for maximum speeds and depth of field.) (Note: Although it wasn't done at Havasu, it is useful to remember that film speed can be upped considerably. Tri-X, for example, can be pushed to 2,000 ASA. High-Speed Ektachrome to 500 ASA. Any custom house can process the pushed film accordingly. You have only to remember to tell him which rolls were pushed.)

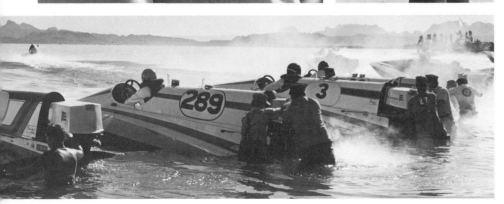

Photojournalism

ANTIGUA SAIL WEEK

And, as a final event, I offer the fairly schizophrenic Antigua Sail Week—schizophrenic as illustrated on this page: one half serenity and cruising contentment or—as they say—cruising, boozing, and snoozing; the other half, flat-out, no-holds-barred racing. To the right is the fleet at anchor at Curtain Bluff. Below is the week's winner, Supercilious, *struggling somewhat under the strain of a massive star-cut spinnaker as she sweeps across the finish line at Curtain Bluff. (Both Pentax, 135 mm lens, Kodachrome II, 1/250 at f/8.)*

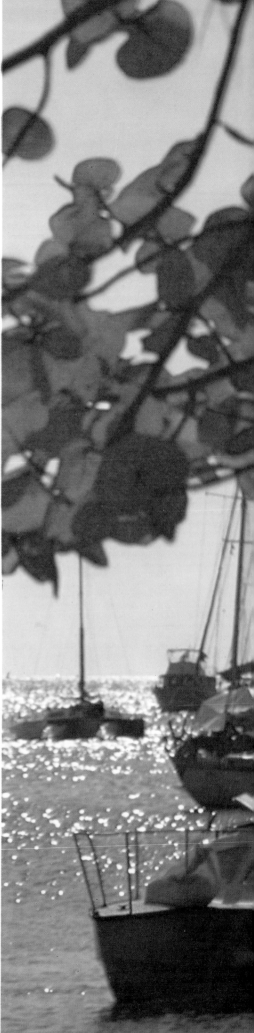

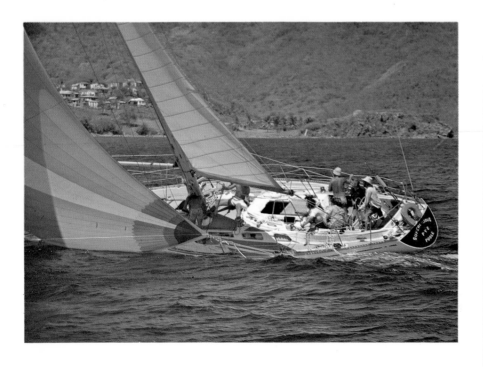

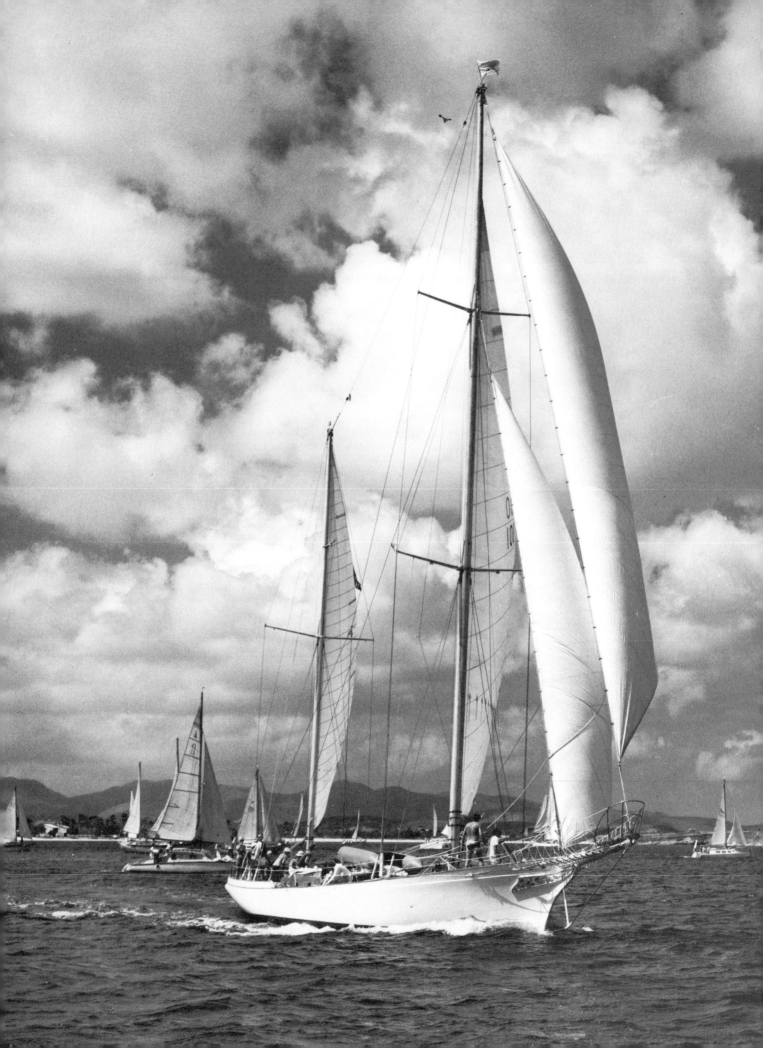

More sailing and racing scenes from Antigua, including one (left) of one of the all-time great yachts, Ticonderoga, looking as fit as ever. To the right we have three assorted racing photos. All three were selected mostly on the basis that they represent ordinary sailing circumstances. Thus, they not only help tell the story of Antigua · Sail Week, they tell something about all sailing races everywhere. (All Pentax with 135 mm lens, except Big Ti, which was shot with the Rollei. Pentax photos shot at 1/500 at f/18; Rollei, 1/250 at f/11.)

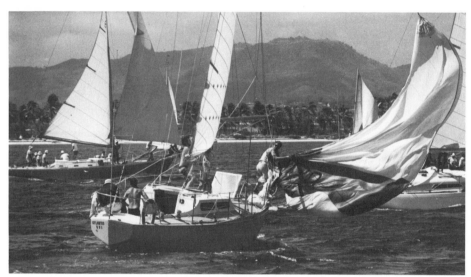

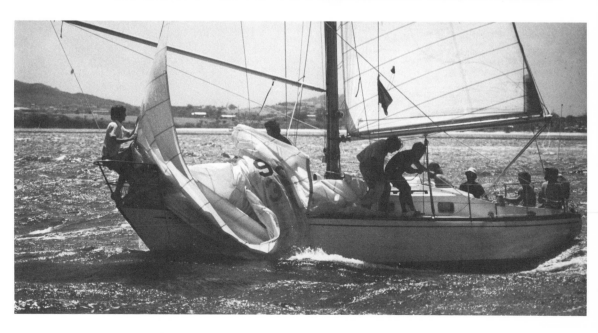

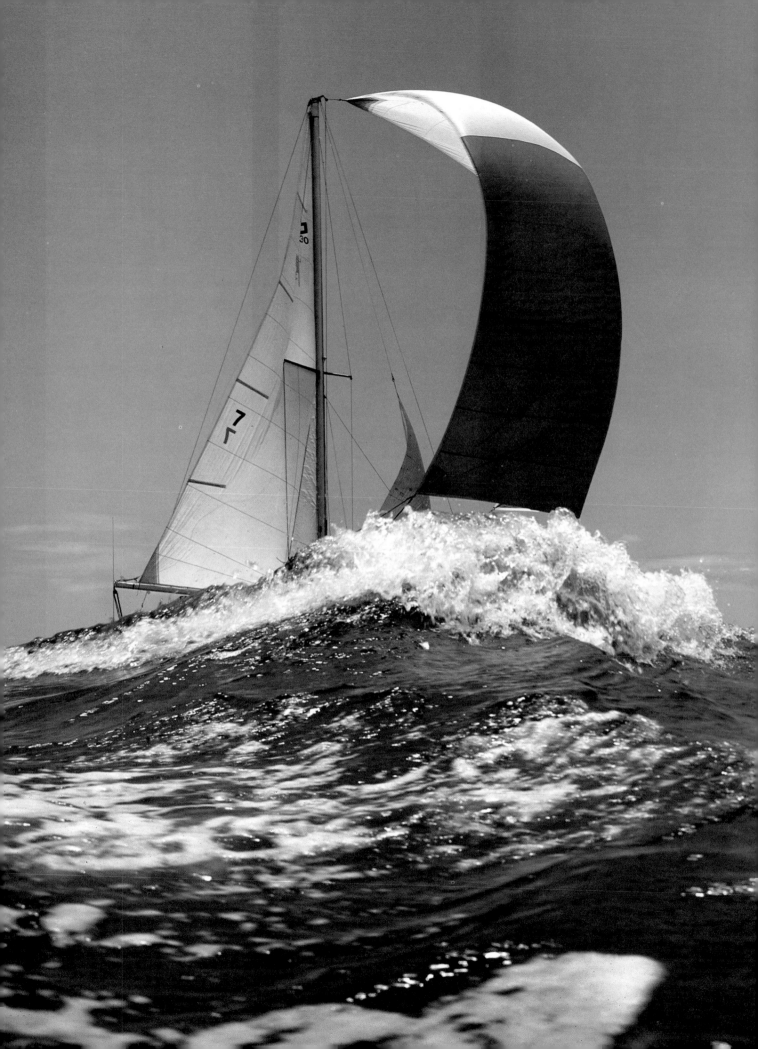

Photographs normally flatten seas, making rough water look like the surface of a mill pond. However, once in a while, if you work at it, the sea can look rougher than it was in life. The sea in this photo, particularly to the uninitiated, looks monumental, but in fact it was only about five feet high. A very low shooting angle and a cooperative wave that broke at just the right time did the job nicely. In my defense, though, I must say that I hung over the transom of the photo boat quite a while waiting for said cooperative wave to appear. Then, too, at times like this a good driver becomes essential. He must know what you want to do and be able and willing to hold the photo boat in position until the right moment happens. (Rollei, Ektachrome, 1/250 at f/11.)

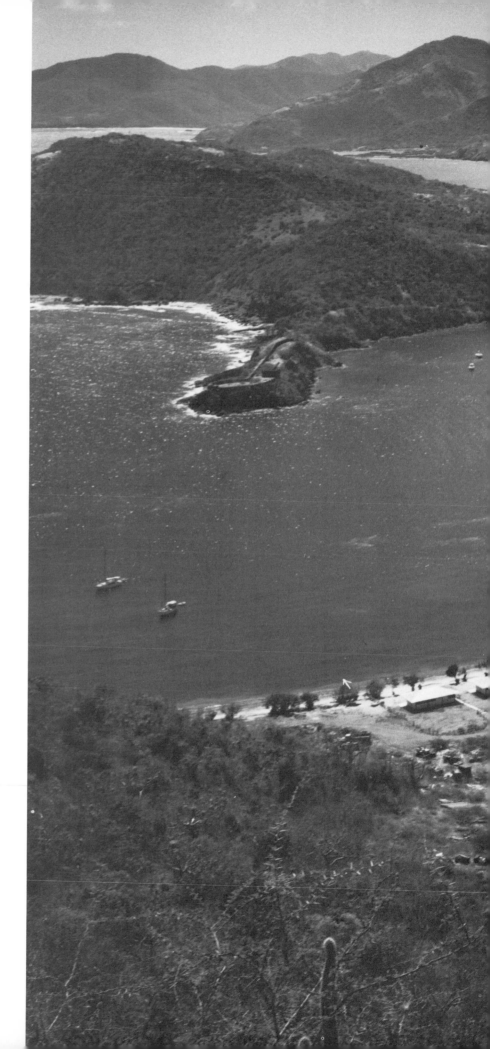

But, racing notwithstanding, the focal point of any Antigua story–at least from the boatman's point of view, has to be English Harbour with its famous Nelson's Dockyard. The Dockyard has ever been and still is one of the prime axes around which Caribbean maritime life revolves. It can be photographed many ways. Its historic details can be shot, the hustle and bustle of arriving and departing yachts can be recorded, but I opted for an overview from Shirley heights–site of the island's major fortification–to show why the harbor was and is such a natural: deep water is very close (left-hand side of photo) yet thanks to the double bend in the channel the dockyard and inner harbor are very nearly weatherproof. (Rollei, orange filter, Plus-X, 1/250 at f/11.)

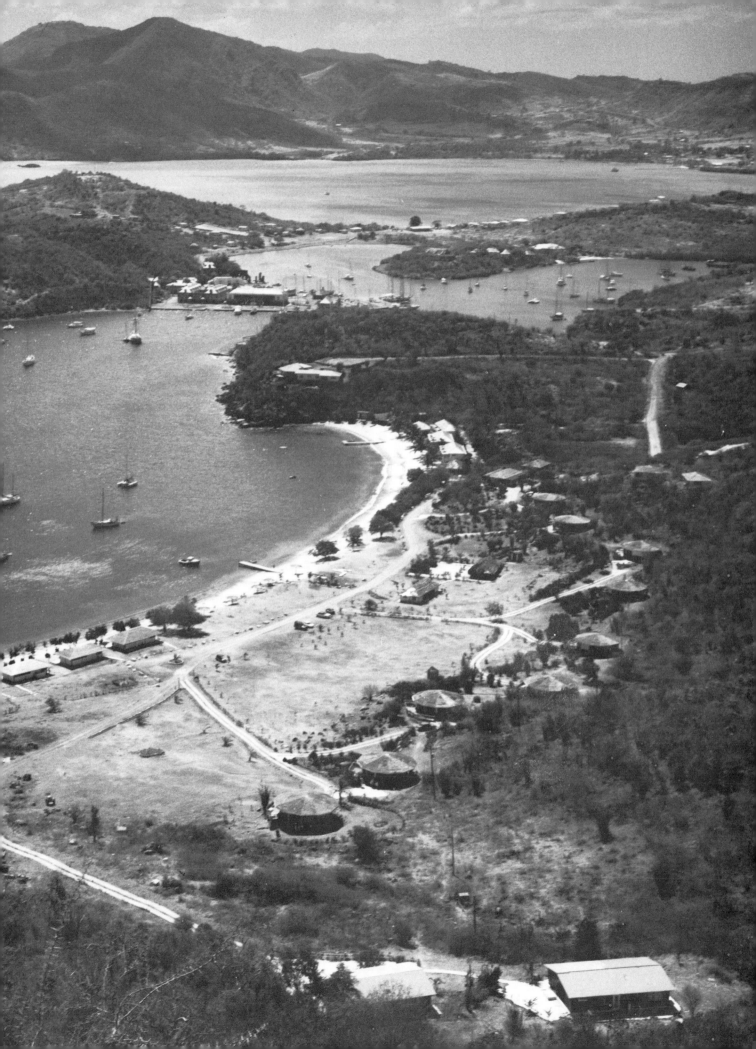

An event like Antigua Sail Week is multi-dimensional, a fact which provides a photographer with considerable challenge and opportunity. The racing—though the focal point of the week—is only part of the story. The cruising aspects of the week are another dimension, while still more aspects are the shoreside activities of the participants—the parties and so forth—and the island itself, a subject worthy of spending a great deal of time with. After all, Antigua has been a pivot around which much of the maritime traffic of the Caribbean has revolved. These days this traffic is cruising yachts, in days gone by it was frigates and lines of battle ships. For many years, Antigua was the linchpin of the British navy in the Caribbean and the island is studded with ruins and reminders, some restored and some not, of the British navy's days of power with Antigua. Unfortunately, just as time limited my exploration of this facet of Antigua, so does space limit me from showing more than one study of the Antigua of yesteryear. This is the wide-angle photo of the ruins of the officers' quarters on Shirley Heights above English Harbour (near left, top). This was shot with a 28 mm lens on the Pentax.

The balance of the photos on this page is also 35 mm photos, all done with a 135 mm lens, a length that is quite useful in that it is short enough to make camera movement not too serious a problem, yet is long enough to bring distant subjects reasonably close. It might be worth mentioning here, too, that all of these photos have been cropped from their full original size. This is one of the major differences between just shooting, and shooting with the awareness that the raw film that comes out of the camera can be and probably will be cropped before it appears anywhere. Without cropping, every frame must be right when it is shot. While cropping is an extra step and will be avoided by most who are just shooting for fun, it is a useful tool to keep in mind when the available lenses simply won't compose a photo properly.

The photo to the right of the fleet at anchor in Halcyon Cove is a virtually un-cropped (except the sides) Rollei photo, a fact betrayed by the sunflare, a flare that occurs only with between-the-lens shutters, never focal-plane shutters.

A Guide to Marine Photography

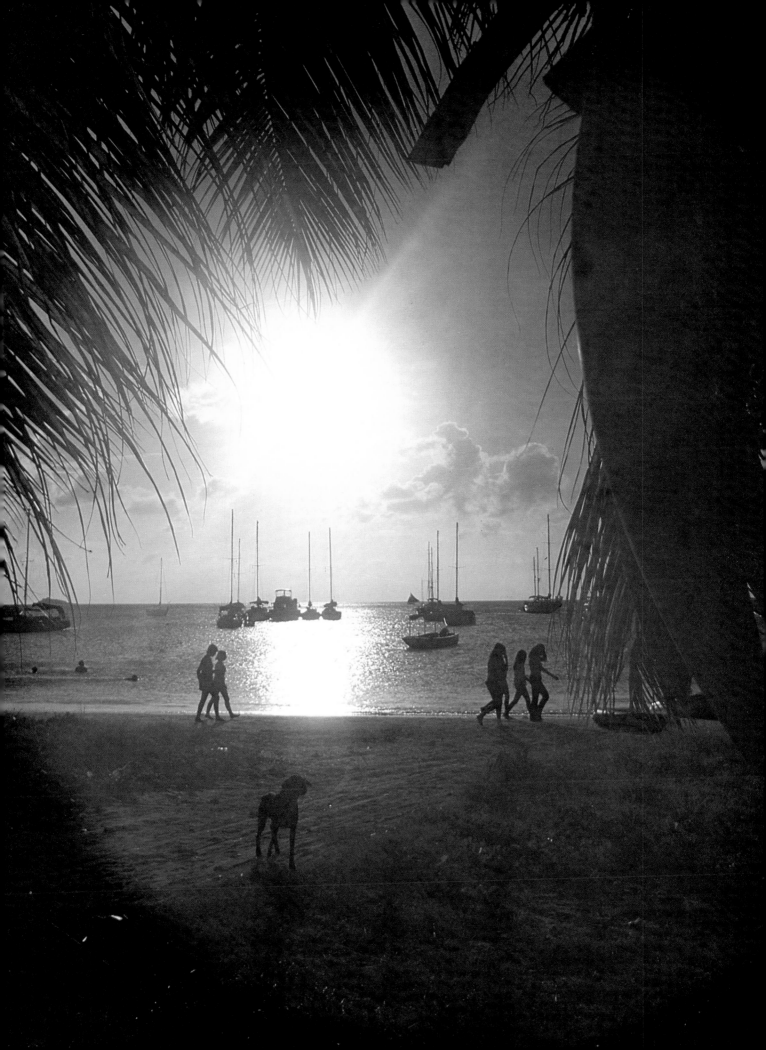

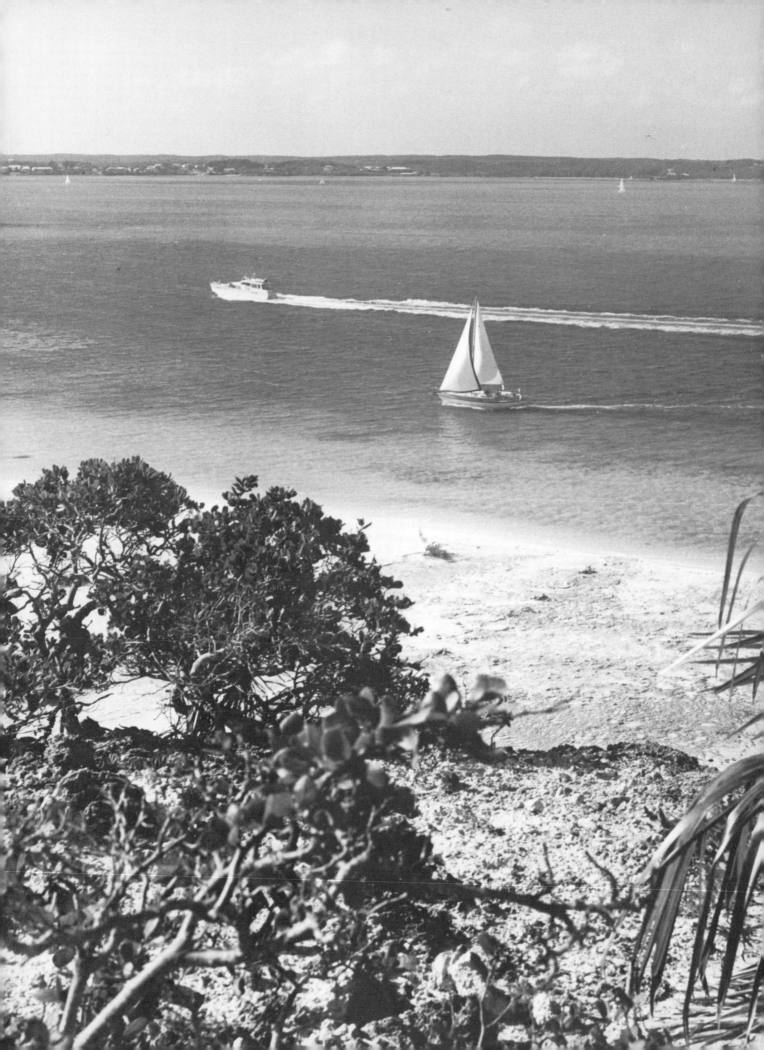

Cruising Photography

One way of opening this subject might be by saying, "The best comes last." At least that is the way I feel about it, since cruising is my own particular thing. I have nothing against one-design, around-the-buoy racing. It is great fun and I do it as often as I can, but I must confess to a total disinterest in offshore racing since to me (a) there is no reasonable way to race different sizes and shapes of boats together and (b) racing over a long distance merely messes up the opportunity to cruise over the same distance. Except for occasional, moonlit night passages, I am of the firm belief that anchors and the sun should go down together.

Another way of opening this subject

One of the more popular cruising garden spots is Stocking Island in the Bahamas. This photo of a Huckins and a Pearson was shot from the highest point on the island. (Rollei, yellow filter, Plus-X, 1/250 at f/11.)

might well be to confess that it is far too broad and large a subject to fit within these few pages. Until now, we have spoken solely of boats, singularly and in company, plus—in the last section on events—the relatively few people who participate or watch them. Now, as we move into the cruising world, we move into a microcosm of the world. It is a world circumscribed by our boats' abilities to cruise it, but within the confines of that world will be found almost every type of thing in the world worth finding and photographing. Thus, a truly competent cruising photographer will have to be, in addition to being a straightforward marine photographer, well-equipped in experience, equipment, and inclination to take on whatever appears, be it a placid harbor, a craggy cliff, a pristine chapel, or a marketplace teeming with arguing, bartering, gesticulating people.

The discovery and exploration of all these things—plus everything else the newly discovered port of call offers—is what makes cruising such an unending source of pleasure, and it's the reason that there are no limits to the amount of time and effort that can be invested in cruising photography, with constantly improving results. I have yet to find the law of diminishing returns in photography.

On the contrary, I know of no easy way to obtain a good set of photographs of a cruise. Successful photos require time and effort and those who envy me my many trips to the lands of the lotus eaters should also be aware that no trip has ever cost me less than five pounds in body weight from an already skinny frame, weight that was burned off in climbing hills, scaling trees, trudging beaches, and lugging too much camera gear too many miles, swatting flies and mosquitos every foot of the way. I am not really complaining, only explaining that hard work is involved in cruising photography. If I have been successful at it, it is largely due to this willingness to expend the required energy, not because I am such a master craftsman with a camera.

Take, for example, the photograph on these pages. It is a nice enough photograph of a Huckins cruiser and a Pearson 390 sloop in Elizabeth Harbour opposite Georgetown in Great Exuma, the Bahamas. It looks as though I was standing there on top of Stocking Island, Rollei at the ready when the two boats happened by. I suppose it could happen that way, provided you took provisions and camping gear to keep you alive until it did. You might have quite a wait.

Obviously, since I'm paid to do other things than sit on a Bahamian hilltop waiting for the right combination of boats to happen by, I arranged the whole thing with the Pearson, as I had her under charter. The Huckins owner was convinced that spending an hour or two zooming up and down

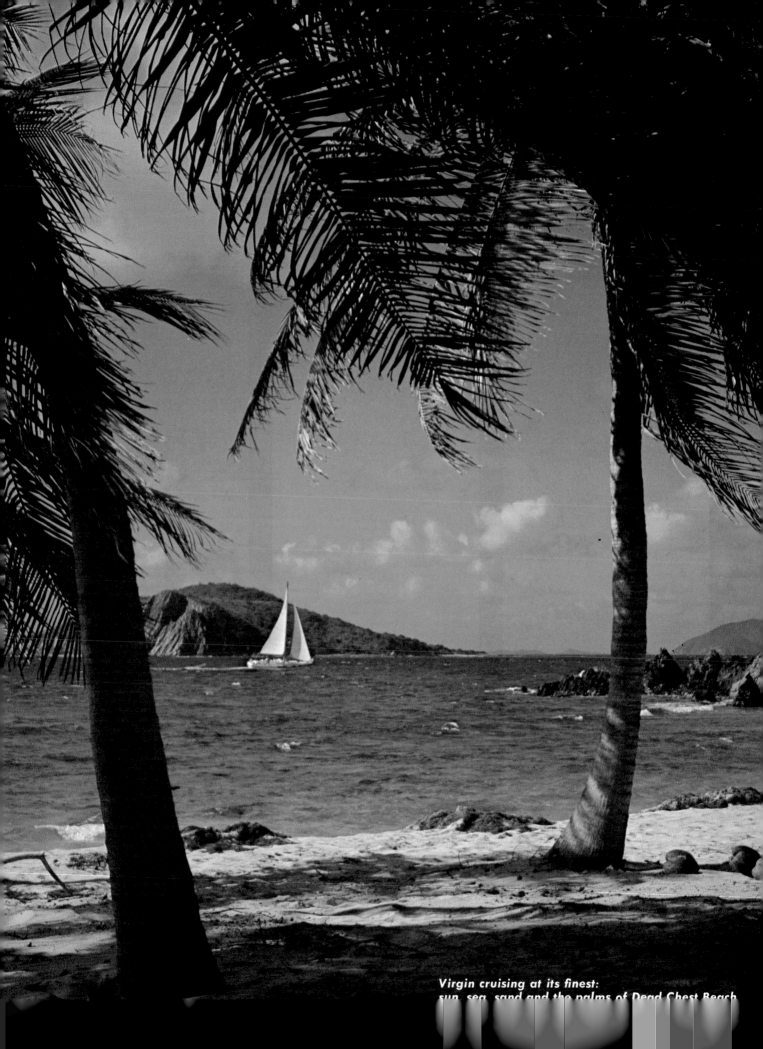

Virgin cruising at its finest:
sun, sea, sand and the palms of Dead Chest Beach.

Elizabeth Harbour might be fun. Getting to the hilltop required rowing ashore and then floundering through a half mile of dense underbrush, and then slipping and sliding up the rubbled side of the hill. As I look at the photograph now, I wonder whether it was all worth it. Maybe it was and maybe it wasn't, but I do know that, in any case, *without* the effort the photograph, worth it or not, would never have been taken.

I am not for a moment suggesting that everyone, however devoted or not to photography, should get this involved or spend this much effort and time, time that could just as well be spent in lazy indolence under an awning. Cruising photography can be approached and satisfaction obtained on any level. Even the simplest of fixed-focus, fixed-shutter-speed cameras can be used successfully if, as pointed out earlier, their limitations are kept firmly in mind.

Whatever your equipment and inclination, cruising photography falls into two general schools of thought. The first is what can be called the sequential story approach. This is merely a photographic story of one specific cruise. It logically has a beginning and an end separated by stops along the way. It is the most normal way for people to shoot any cruise or trip they take. It is uniquely theirs, and, in that context, is an okay thing to do.

The second school for thought might be termed the area approach. This is more along the lines of the cruising guide approach, covering the area involved at least as well as a sequential story would. It is more impersonal than a sequential story and in this lie its biggest weaknesses and its greatest strength. What it lacks in uniqueness of specific people on a specific cruise is made up by the possibility of achieving some level of universality in the photographs. I personally prefer the latter

approach, in which Island X changes from an island I visited to a geographic entity visited by many, and hopefully even attains overtones of everyman's island.

The same duality of purpose can and does run through all areas of cruising photography areas, which, for purposes of simplicity and discussion, include: underway photographs; people on board or life afloat; destinations: in port, at anchor, harbors, waterfronts, and the people around them; and finally the people, places, and things that, in sum, make each destination or port of call unique.

All of these things can be photographed from both points of view. On board you can take a picture of cousin Harry at the wheel, but you can also try for overtones of everyone who has ever stood a wheel watch. Similarly, you can shoot your boat at sundown, but with effort and luck you can make her stand for many boats riding to many anchors.

In this regard, though, a conflict may arise, a dividing in the road, so to speak, between ''our'' cruise and every cruise. The separation comes when your boat looks okay at anchor, but another—by virtue of surrounding land, cloud formation, sun direction, or whatnot—looks considerably more appealing. The pure sequentialist will shoot just his own boat, his counterpart only the best available photo. You can take your choice, or in fact—as I would probably do—shoot both.

Having shot many, many cruising photos, I have had my share of mistakes. Most of these fall into discernible categories. These include trying to show too much, lack of humanization, and lack of planning and forethought. I could add to these the general sins of commission and omission that seem to plague all photographers, but these three will do very nicely.

We will cover the pitfalls of trying to show too much, and the dullness that comes from lack of humanization a little farther on. For the moment, we will speak of lack of planning and forethought, twin evils that take two forms and can be alleviated in two ways —advance planning and on-the-spot planning.

Advance planning means, in essence, that you have some idea of what you are doing when you step ashore. It means, more specifically, that you did your homework about the place in question and have obtained enough background to enable you to have a sense of perspective about what you are seeing. This information can be obtained from cruise guides, local chamber of commerce tourist offices, and the local library. Lest you think that I am speaking solely in terms of exotic islands, be assured that I'd do the same amount of research for a cruise up the James River in Virginia as I would for a cruise through the Windward Islands.

On-the-spot planning and forethought means thinking and seeing as a camera does. It means searching out the best locations and visualizing them under different light conditions. What may be a bummer when you see it in the morning may be glorious at sundown.

It means seeing a line of palms along a beach of golden sand and knowing that if you snap the shot from the deck of the boat, all you will get is a fuzzy green and gold blur. But it also means that you can visualize how nice a photograph would be if you went ashore, walked well into the palms, and shot the boat sailing past. You would, in fact, end up with a photograph very similar to the photograph on this page. Which is precisely why I wrote that last sentence, to underscore once again that (a) good cruising photographs are to be seen and (b) once seen they are there to be taken, if you want to.

Advices and Devices for the Cruising Photographer

As stated on the previous pages, cruising photographs suffer most frequently from two major faults: trying to show too much and a lack of humanization. In a way the two are related but for simplicity's sake we'll discuss them separately; humanization on these pages; trying to show too much on the pages that follow.

I'm not sure humanization is the right word to describe the attribute I see lacking in many photographs, nor can I pretend that it is a cure-all for every-thing. Sometimes humanization is the wrong thing to try for.

By the word "humanization" I mean to include a person or part of a person in a photograph, not to turn the picture into a portrait, but as an integral part of the photograph and supportive of the basic subject of the photograph. Perhaps the best example that comes to mind was my stint in photographing boat interiors. While it is true that some yacht interiors are so lush and beautiful that adding anything would only detract from the décor, most interiors need one or more people so that the viewer can relate and identify himself to the interior. One person in the photo can and will snap the whole interior into focus in the viewer's mind. Subconsciously, he will gauge the size, spacing, and arrangement of the interior in relation to the person in the photo. (Naturally, we used this fact to our advantage by populating the smaller cruisers with truly minute people. At one point I had the largest stable in captivity of models under five feet tall.)

More in line with the subject at hand, though, is the use of people in cruising scenes. Here they serve two functions. The first, as with the boat interiors, is to give scale to the scene. In this regard, boats themselves, or other readily identifiable things, can function as people would in giving dimensions to an otherwise dimensionless photograph.

The young man swinging into the water (top) humanizes this otherwise dull shot of a lock on the Rideau Canal (bottom).

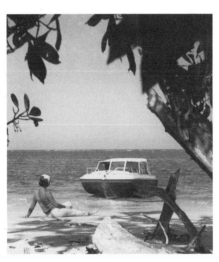

These photos of a boat, a beach, and (top) a girl also demonstrate how a figure can improve a dull photo.

The boat in the photo above makes Diamond Rock look as big as it really is. Without the boat, the rock could be any size.

People and/or other identifiable objects (like boats) will give instant scale to everything in the photograph. Something that is large in fact may appear to be small unless it is contrasted with something whose size the viewer instantly recognizes. Several examples of this kind of photograph are shown here.

The second reason to humanize cruising photographs is more subtle and as a consequence more difficult. It is perhaps best expressed by saying that people identify with people more easily than with anything else. For example, an empty beach, no matter how lovely, will ordinarily photograph as a lifeless, featureless expanse of sand. But, put a person on it either walking along it or lying on it or beachcombing and suddenly you have a scene that everyone can and will identify with.

Similarly, an on-board scene will gain tremendously in impact by having a person in it related to the rest of the photo, especially if that person is, by pose, gesture, or expression, complementing the emotion evoked by the rest of the photograph, for example, tense, on-guard people in rough-water photographs, serene peaceful people in placid photos. I have one photograph that is not in this book. It was taken on a miserable, knockdown and drag-'em-out day in the 1966 Bermuda race. It was two reef and #3 jib weather with squalls and general Gulf Stream nasti-ness, yet the helmsman, of whom this was a photo, is smiling away. The fact that his smile was merely betraying his intense nervousness is beside the point. The photo was a study in contradictions and hence was more confusing than anything else.

And, it must be said that there are times and places where no people are better than anything else. Humanization is no cure-all, and sometimes the scene being shot is so right already that the addition of any element, human or otherwise, would merely detract from and overcomplicate the photo. This leads us directly to the problem of trying to show too much, a subject we will dive into on the following two pages.

Peter Island Beach is pretty but, like all beaches, photographs poorly without someone, like my daughter, sitting on it.

However, sometimes adding a human is the worst thing to do. How could any addition do anything but detract from this photo of the cloister on Paradise Island in Nassau?

Details
Tell Tales

Probably the biggest single fault in all cruising photography is the desire on the part of the photographer to tell much and the ability of the camera to capture little. Cameras, even the best, are very limited devices. They have but one sense and a limited one at that. They can see but only within the narrow scope of their lenses. They cannot smell, they cannot feel, they cannot hear, and they cannot taste, but the human holding the camera can and does all of these things. He is aware of all of these sensual inputs and his natural desire is to record all of them. In taking a photograph he is trying to capture the

scene in all of its ramifications, to either help him relive the experience later on or to share it with others. His natural instinct is to aim the camera at the scene that holds him in thrall and snap the shutter, only to discover when he sees the result that the camera missed 90 per cent of the emotional content of the original scene. It isn't the camera's fault. It can only do what it was built to do. The only viable procedure for a photographer to follow is to work within the camera's limitations.

Most often, this will mean eschew-

ing the grand and the glorious in favor of the limited. It can be summed up by saying: Find the details that signify the whole; let a wave signify the ocean; a palm, a tropic paradise; a rock ledge, the entire coast of Maine; a smiling lad, the happy disposition of a people; a headboard shackle clipped to the lifeline at sunset, all peaceful harbors everywhere. There is no limit to this except one's ability and imagination at finding those things that a camera can cope with and that will, when seen, instantly conjure up the rest of the original scene.

This process of simplification (for that is what we are talking about in a

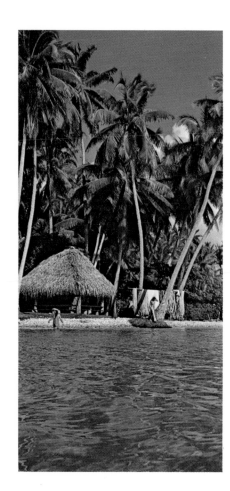

way) works in reverse for the viewer. Any viewer of any photograph has an entire lifetime of experience, experience that allows him to create in his mind's eye the entire ambiance in which the photo was taken. For example, show a boatman a photograph of an anchor just breaking water, the sun glinting from its wet and maybe muddy surface, and instantly the boatman's mind will be filled with scenes and emotions of his own departures. The scenes he creates may not be the ones you photographed but the emotional content will be the same.

And that is the name of the photographic game. Anyone can take snapshots of Harry and Fred hoisting the anchor aboard on your cruise last summer to Bent Prop Island. If that's what you want to do, so that you can all get together during the winter and chuckle over the things you did last summer, all well and good. Go with God and have fun.

But if you want to go another step further, to make your cruise important to others as to yourself; to shoot your cruise so that others who wouldn't know Harry from Fred and could care less identify with you and feel elements of *their* cruise in your cruise; and to shoot the cruise so that the photographs speak of the perils and pleasures inherent in all cruising, then your work is cut out for you. And so are your rewards.

Detail photos of people and things taken during a cruise in the Society Islands; an attempt in ten photos to describe life in the islands—from the tourism to the tin shack in the out islands, from the hustling commercialism to the lovely and languid lagoons. (Mostly Rollei photos on Ektachrome, mostly 1/250 at f/11 except cave photo, which was 1/30 at f/5.6.)

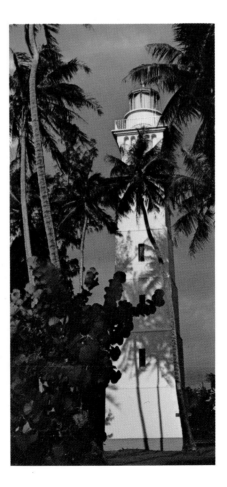

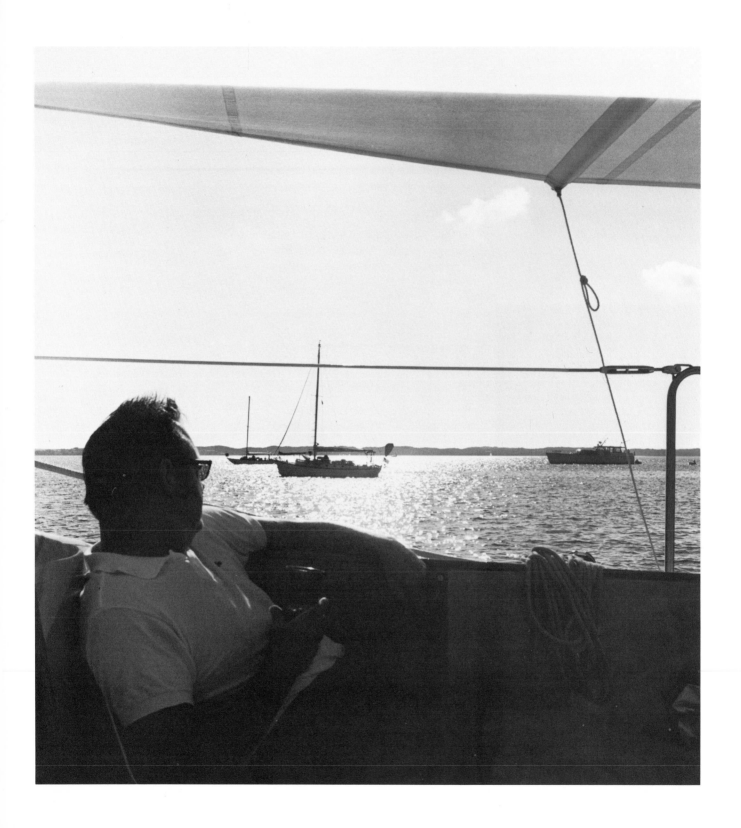

A Guide to Marine Photography

Two faces of cruising. At left is long-time publisher of Motor Boating & Sailing *John Whiting doing applied cruising research at sundown in the Bahamas. To the right is a scene in the lock at Little Falls on the Erie Canal on a cold, cold early spring day. I like both of these photos since they manage to grasp the essence of two divergent aspects of cruising. (Left, Rollei, Plus-X, 1/250 at f/8; right, Yashica, Tri-X, 1/125 at f/11.)*

Putting It All Together

You will recall I earlier said that there were no laws, no rules to photography. I also said that two of the keys to shooting are (a) the ability to visualize and (b) the willingness to explore a subject to uncover its various aspects. Additionally, from time to time throughout the book we've discussed various lenses, various kinds of light, and, in sum, all the details that go into a photograph.

Ordinarily, one doesn't have the time or the inclination to keep working with a particular subject as much as one really ought to if the best is to be extracted. Let's face it, the one thing few of us have enough of is time. Like everyone else, I'm all too likely to fall into the habit of doing something well enough quickly and moving on.

However, once in a great while, circumstances will conspire to allow us the opportunity to work with one subject over a period of time. It is an opportunity to be cherished and taken every advantage of.

One of the few such opportunities I've enjoyed was to have been housed in a Tahitian hotel room opposite the island of Mooréa. Over the course of several days when nothing much else was happening I shot the island. I shot it at dawn and at sunset. I shot it with long lenses and wide-angled lenses. I shot it every way I could think of, both from

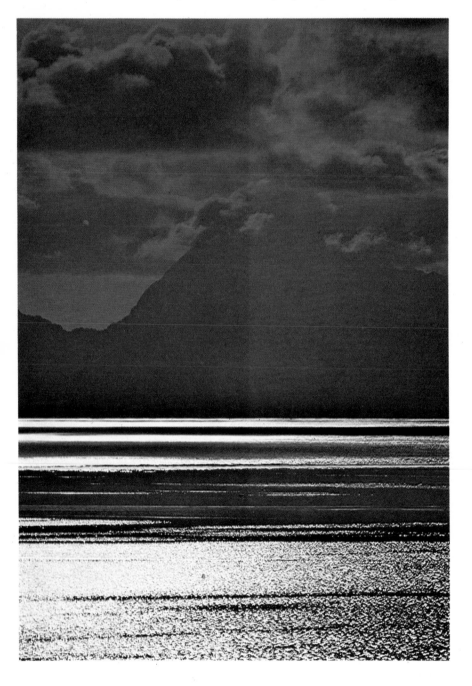

the room and later from a boat.

The best of these photographs are shown here as a representational selection of what can be done with one island (or one of anything) if sufficient time (along with sufficient motivation) is available.

The 200 mm sundown photo (far left), the 135 mm late afternoon photo (below), and the 28 mm dawn shot were taken from Tahiti. The 200 mm shot was done in Cook's Bay, Mooréa. All were Pentax photos on Kodachrome.

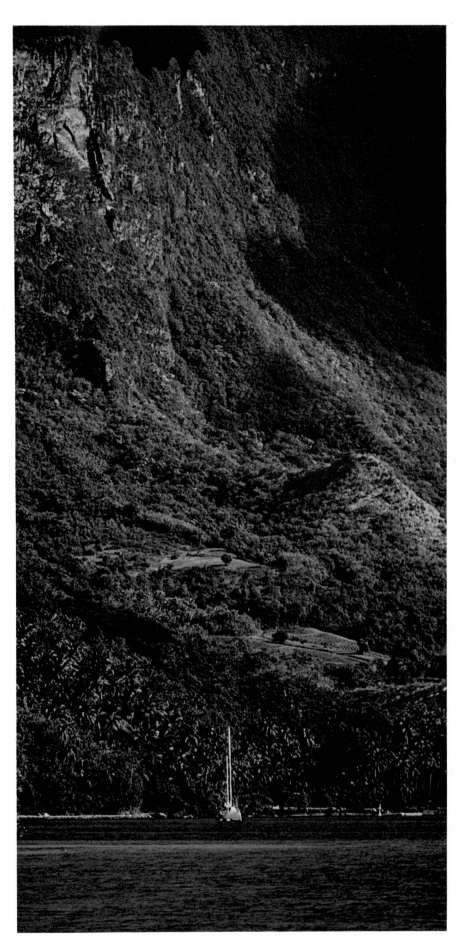

Three aspects of life on board. It should be obvious that this group was selected on the basis of their dissimilarity to illustrate the very broad spectrum of possibilities in shooting on-board, underway cruising photos. The young woman in the upper left was photographed from a Miami bridge as the boat she was on passed underneath. The lower left photo is of my son discovering the world again early one morning on a cruise to Cape Canaveral. The photograph to the right was taken aboard an Annapolis 44 homeward bound on Long Island Sound. It was a glorious day to sail and I think this picture captures that feeling. (Left, Rollei, Tri-X; top: 1/500 at f/16; bottom: 1/125 at f/5.6. Right, Pentax, 55 mm lens, Tri-X, 1/1000 at f/16.)

A Guide to Marine Photography

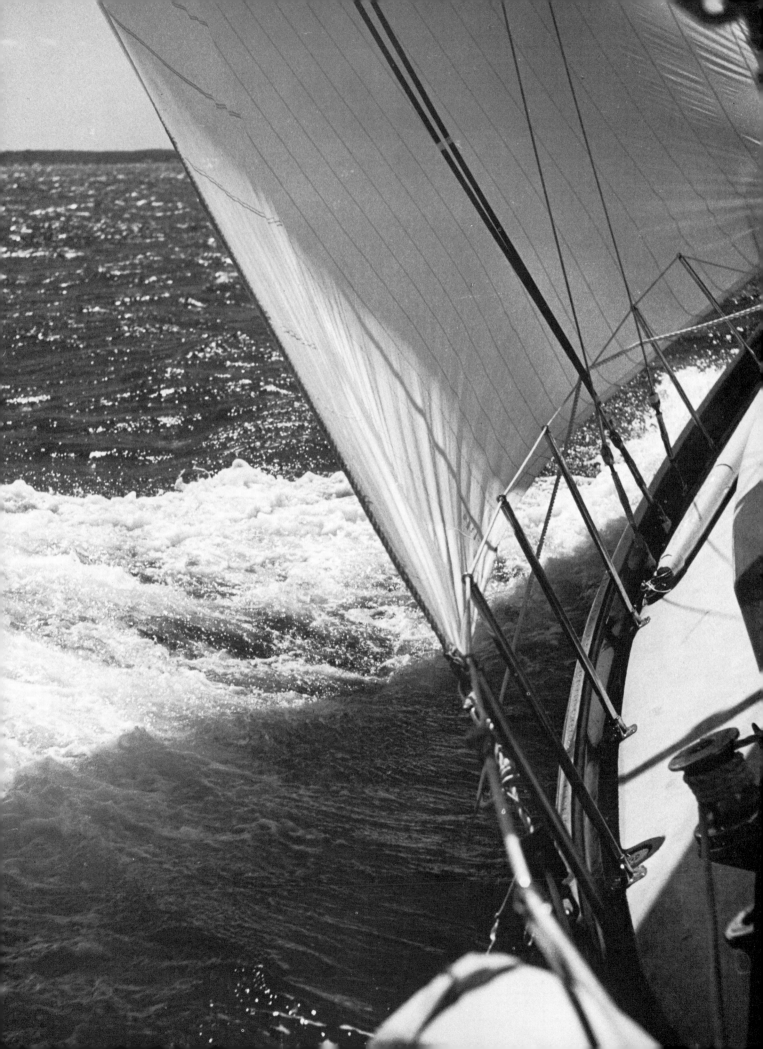

It is dawn on the way to Raiatéa and everything is obviously all right with the world. Of all the photos I've ever taken, this has to be among my few favorites, not only because I was there but because every time I look at it, it reminds me why we all put up with the hassles of seagoing. A dawn like this can make a lot of hassles worthwhile. (Rollei, Ektachrome, 1/60 at f/8.)

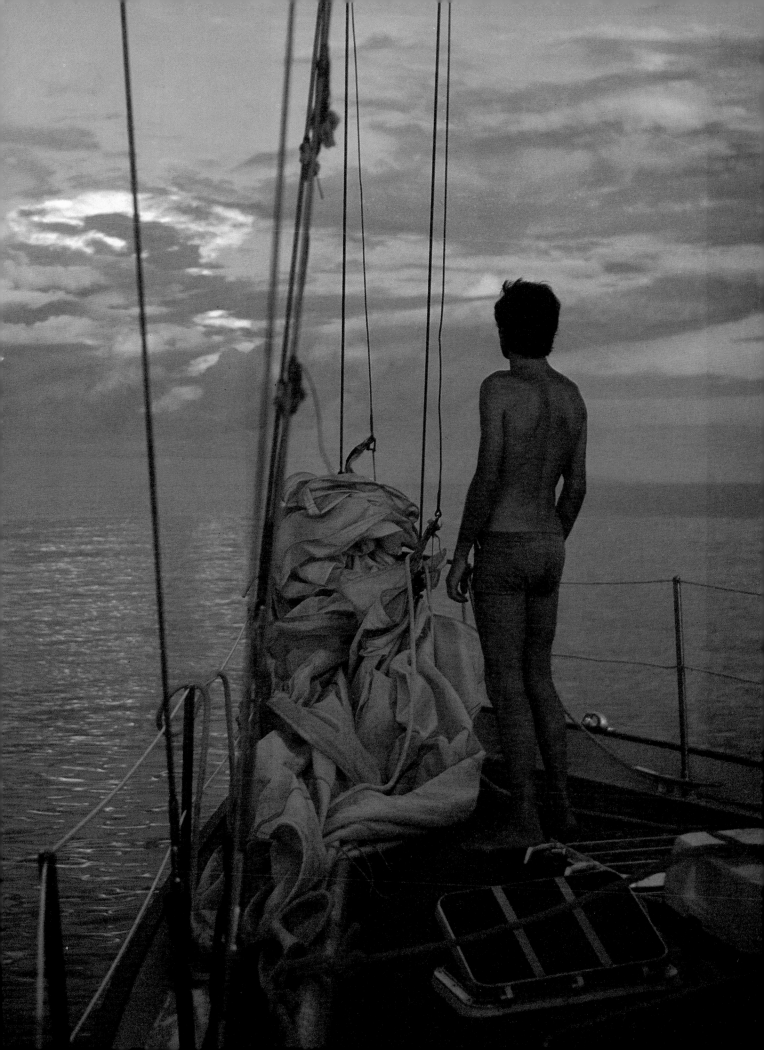

A Guide to Marine Photography

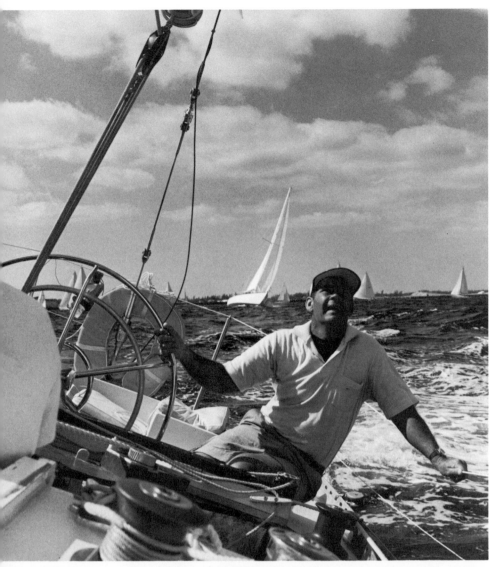

More photographs of life on board, taken here and there of people doing this and that. Clockwise from near left we have: Jack Sutphen (Courageous's tactician) at the helm of Bones during the 1972 SORC; Jim Bister counting Consolan dots during the 1966 Bermuda race while skipper Morty Engel catches a nap; Ingrid Avery enjoying a bath in a bucket; Elly Dowd trimming a jib on a cruise in the Virgins; Sydney Smyth just enjoying himself on a bowsprit in the Gulf Stream; John Walter attacking a coconut with hammer and screwdriver; crewman going aloft during the SORC. (All Rollei except bucket bath, which was Yashica with Verichrome, and below-decks photo, which was Pentax with 28 mm lens and strobe light, the only photo in this book not done with available light.)

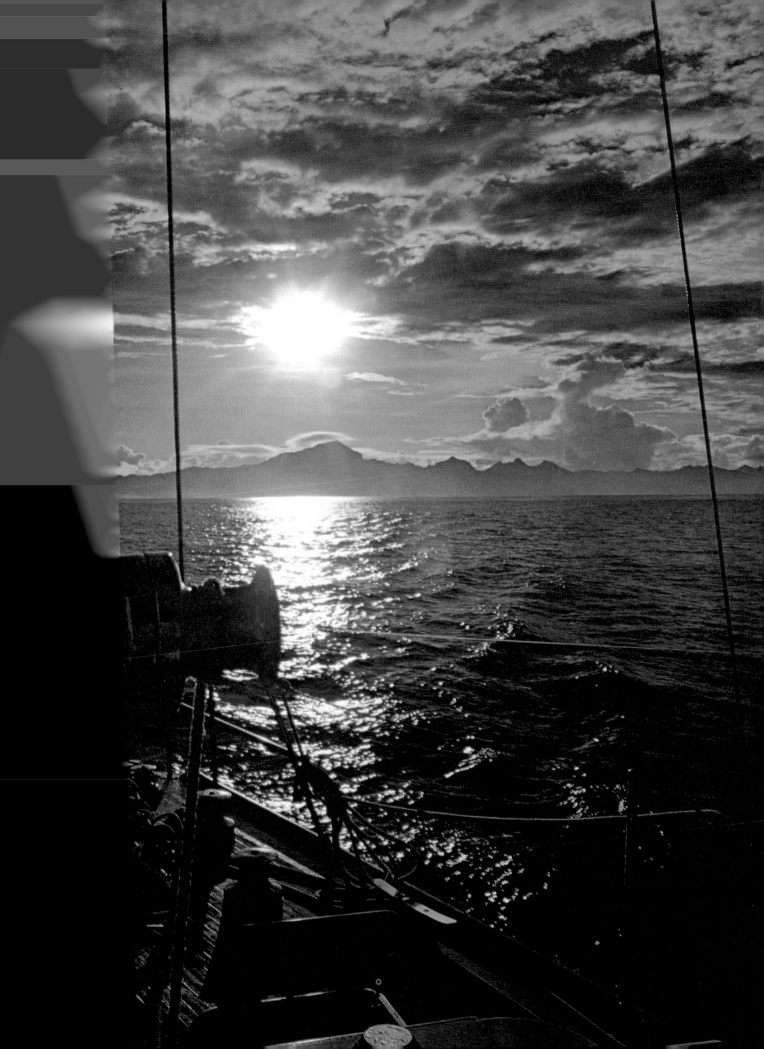

Two of cruising's better moments are exemplified in this pair of photos: making a landfall and a peaceful afternoon in port. The photo (left) of Huahiné in the Society Islands was done with a Nikonos camera with a 35 mm lens on Kodachrome just after sunrise. (1/250 at f/11.) The shot to the right was done through the deckhouse door of a trawler anchored in Key Biscayne's No Name Harbor. The little sloop with the red sails has a lot to say about the sheer, no-pressure fun of gunkholing around a harbor in a small boat. (Rollei, Ektachrome, 1/250, at f/11.)

Putting It All Together

Waterfronts and harbors play a leading role in any cruising man's life. This is a collection gathered from here and there. To the left, top, we have a houseboat entering a lock on the Rideau waterway, while below it we have a chartered cruiser tied up along the lush and lovely Marne River in France. On the right (top) there is a scene of a small gathering aboard a Morgan at the Peter Island Yacht Club in the soft and warm Virgins, a scene in direct contrast to the stern and rockbound Maine coast at Pemaquid Point, below. (The two upper photos are Rollei with Tri-X, the two lower ones, Yashica with Verichrome.)

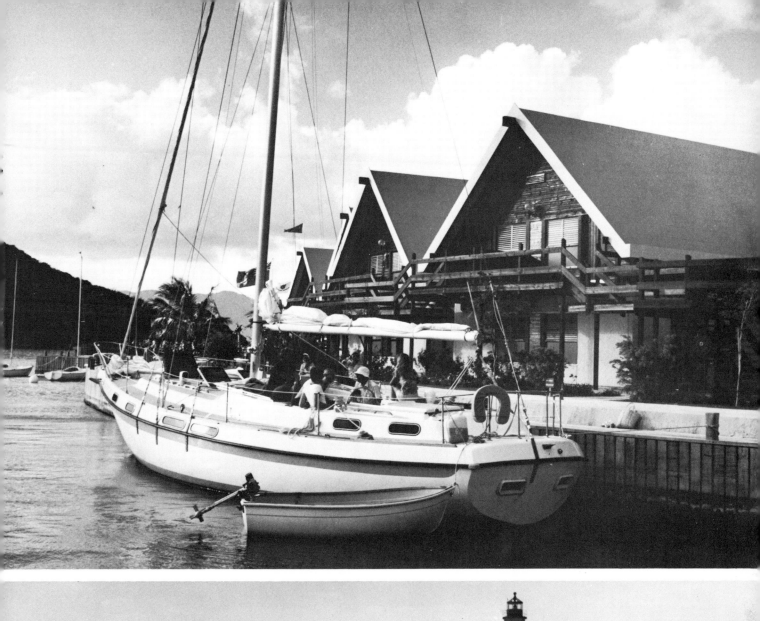

Another pair of typical cruising photographs, one planned, one not planned. The unplanned one is the catamaran Margay secured to the palms at the Pitons on Saint Lucia. In some ways it tells you everything you need to know about cruising the Caribbean. The bucket photo was staged mostly because it is somewhat ridiculous to sit by the bow of a boat in a dinghy and wait for someone to come along and throw a yellow bucket over the rail to get a pailful of wash-down water. It's done all the time in every cruising harbor clean enough to do so, but to take a photo of it requires staging unless you're a lot more patient and lucky than I am. (Both Rollei, both Ektachrome. The bucket photo was exposed 1/250 at f/11, Margay at 1/125 at f/8.)

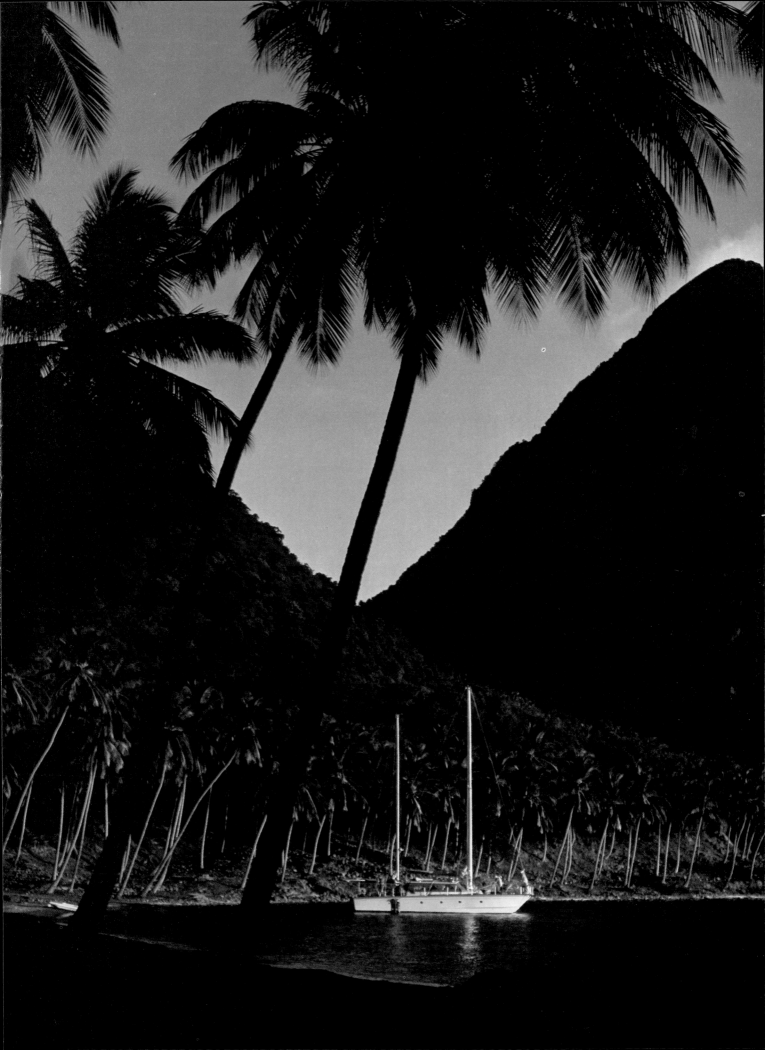

Slightly away from strictly marine photography, but still very much a part of cruising photography are studies of the interesting, unusual, and photogenic people one finds on a cruise. The woman with her bananas was taken in Barbados, the sailmaker was in Bequia, and both have something to say about the simplicity and slow pace of life in the Antilles. (Both Yashica on Tri-X, both about 1/125 at f/11.)

A Guide to Marine Photography

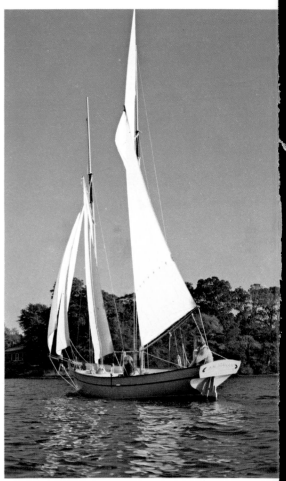

A Guide to Marine Photography

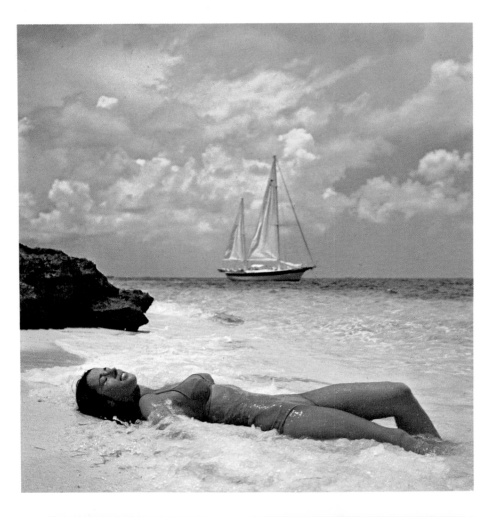

More facets of the cruising world, or in a broader sense, the boatman's world. Clockwise from far left: a couple enjoys a quiet walk along Pennsylvania's defunct Delaware Canal below New Hope; a miniature Baltimore Clipper graces a gunkhole in upper Chesapeake Bay; a young woman graces one of the countless white sand beaches in the Bahamas—this one at Gun Cay; exploring Santa Cruz harbor by oar power; an afternoon outing on Raiatéa lagoon in the Societies; examining the inner workings and hidden mechanisms of a sugar mill on Saint John in the Virgins.

The range and possibilities of photographs on and around the water is endless, limited only by a photographer's imagination and willingness to explore each subject, searching out the best angle, the best lighting, in order to say something special, something uniquely yours, about whatever it is you are trying to photograph.

(All Rollei with Ektachrome, except the sugar mill, which was Yashica, and the rowing photo, which was a Pentax with 200 mm lens and Kodachrome film, 1/500 at f/5.6. Other exposures were about standard for bright sunlight: 1/250 at f/11.)

For one reason or another, I consider these three to be among my best black-and-white cruising photographs. Each portrays one of the major attractions of cruising, or more correctly, three different ways of expressing the basic emotional appeal of cruising: a combination of the thrill of exploration and the serenity and peace of all good cruising ports of call anywhere. The cruiser at dawn on the Marne River (lower left) is one expression; the young woman beachcombing on Deep Bay in Antigua is another; while my daughter and a friend walking back to the Coral Harbour dock after grocery shopping while a Saint John donkey ignores the whole thing is yet another. (Both left-hand photos, Yashica, Tri-X, 1/250 at f/11. Right-hand photo, Rollei, orange filter, Plus-X, 1/250 at f/16.)

Putting It All Together

And, here it is, the end of the day and of the book, and what can possibly be said in words that equals what the photo says already? Only, I suppose, that the boat is Moerangi *and she's anchored in the lagoon at Raiatéa, and that to take the photo I perched the camera and tripod on a reef and waited and shot, waited and shot, as the sundown progressed from blue to pink to livid red and finally faded through mauve into the grays of night. As mentioned earlier, at times like this, wide bracketing is essential, so to obtain this one photo a con-siderable amount of film had to be burned up. The camera was my trusty* Rollei, *the film* Ektachrome, *exposed at 1/4 at f/8.*

Taking this photo was a labor of true photographic devotion since half of me would far rather have been lying in Moerangi's *cockpit and allowing the splendor of the evening to wash over me. But, and maybe this is why photography is so important to me, by expending the effort and recording the scene I can relive that evening whenever I choose—and I can share it with you.*

Commercial Photography Possibilities

As with any other art, if you're good, there's a ready market for your work. The boating magazines buy material continually, as do many newspapers. Sports, travel, airline, and even photographic magazines represent secondary markets worth keeping in mind. Additionally, advertising agencies will often use stock marine photos in ads.

All of these outlets will primarily use color transparencies or black-and-white prints. Color prints, unless they are truly exceptional and very well printed are basically a waste of time in the commercial world.

Magazines, which I am most familiar with, are looking more for sets of photographs that will illustrate a story, or which will stand alone as a story in and of themselves. Single shots are hard to use except as front covers. Naturally, every photographer in the world would like to have his work on a cover but the chances of making it are about as remote as shooting a rapidly running mouse at the bottom of a well on a very dark night. If you insist on trying (and God bless you for not giving up easily), keep in mind the normal cover format, which is vertical, with the center of interest in the lower right third. The left side and upper portion of the photo must be clear enough of confusion to hold the cover lines, the blurbs, which seem to be necessary for newsstand success. Also keep in mind that printers these days seem to be incapable of holding subtle pastel tones. And, even if they could, pastel covers sink without a trace on the newsstands. Bright, hard colors seem to work better. Pretty sunsets, for example, almost always bomb.

Photo stories can be either black and white or color depending on the magazine. If black and white is indicated, proof sheets, along with one or two prints to show the quality inherent in the negatives, are not only adequate, but preferred by many art directors. Proof sheets give them the latitude in laying out a story. And it gives them the full range of what you shot to choose from. This latter point holds equally true for color transparencies. Edit out the badly exposed, the truly poor photos, but be careful how closely you edit the "good" photos. Preguessing an editor's or art director's taste is usually poor practice. How can it be otherwise since every honest one will tell you that he himself doesn't know what he wants until it is on his desk?

And, finally, don't use a magazine's back issues as a sole guide to what is being looked for. Magazines would never progress if they weren't continually searching for new ground to plow up. Freelance photographers can aid materially in the search by sending in what they feel is right, even though it might represent a departure from the published norm. Do send it in, also. Don't send a letter asking if they'd like to see such and such. How can they tell without seeing it? And speaking as an editor, they do want to see it. You'd be amazed how hungry the magazine world is for good, fresh, new material.

AFTERWORD

That is it, photo fans. We have come to the end of the road. I have told you everything I know—at least everything I remember—and in the aggregate I wonder if it is enough. I guess that's because there really isn't that much to taking good photographs on and around the water. At least, there isn't that much that can be described as words of wisdom. As I said back near the beginning, there are few secrets in marine photography. It is, from a technical point of view, a very simple sort of photography, a fact disclosed by the similarity in most of the exposures shown throughout the book. Easily half of the photos in this book *could* have been done with a fixed-focus, fixed-aperture, fixed-shutter-speed camera if there was one available with a good enough lens (and provided the focus, aperture, and shutter were fixed at the right settings).

However, although marine photography is basically simple, it does have its complications and frustrations. These are mostly of an entirely practical nature such as being able to get to the right place at the right time to take the photo, and having enough patience and fortitude to hang in there until everything works out. Often it won't, but once in a while it will and when it does the satisfaction of achievement will far outweigh whatever frustrations were endured along the way.

So, good readers, may your lenses stay dry and the sun stay out. Man your cameras and have at it.